Shojo Fashion Manga Art School

How to Draw Cool Looks
and Characters

Irene Flores

IMPACT
CINCINNATI, OHIO
www.impact-books.com

Other fine IMPACT Books are available from your local bookstore, art supply store or visit us at our website www.fwmedia.com.

15 14 13 12 9 8 7

DISTRIBUTED IN CANADA BY FRASER DIRECT
100 Armstrong Avenue
Georgetown, ON, Canada L7G 5S4
Tel: (905) 877-4411

DISTRIBUTED IN THE U.K. AND EUROPE BY DAVID & CHARLES
Brunel House, Newton Abbot, Devon, TQ12 4PU, England
Tel: (+44) 1626 323200, Fax: (+44) 1626 323319
Email: postmaster@davidandcharles.co.uk

DISTRIBUTED IN AUSTRALIA BY CAPRICORN LINK
P.O. Box 704, S. Windsor NSW, 2756 Australia
Tel: (02) 4577-3555

Library of Congress Cataloging-in-Publication Data
Flores, Irene.
Shojo fashion manga art school: how to draw cool looks and characters / Irene Flores. -- 1st ed.
 p. cm.
Includes index.
ISBN 978-1-60061-180-3 (pbk. : alk. paper)
1. Comic books, strips, etc.--Japan--Technique. 2. Cartoon characters-- Japan. 3. Figure drawing--Technique. 4. Clothing and dress in art. I. Title. II. Title: How to draw cool looks and characters.
NC1764.5.J3F66 2009
741.5'1--dc22 2009016095

METRIC CONVERSION CHART

TO CONVERT	TO	MULTIPLY BY
Inches	Centimeters	2.54
Centimeters	Inches	0.4
Feet	Centimeters	30.5
Centimeters	Feet	0.03
Yards	Meters	0.9
Meters	Yards	1.1

Edited by Jennifer Lepore Brune
Cover design by Wendy Dunning
Interior designed by Wendy Dunning and Doug Mayfield
Production coordinated by Matthew Wagner

ABOUT THE AUTHOR

Irene Flores was born in 1982 in the Philippines and currently lives and works in California's central coast. She started her career in 2004, co-creating and illustrating *Mark of the Succubus* for TOKYOPOP Inc.

Irene has illustrated "Weekly Weird News" for the *Princess Ai: Rumors From the Other Side* anthology, and "Right to Left, Back to Front" for WildStorm's *Welcome to Tranquility*. She is currently illustrating projects for WildStorm Productions.

Visit Irene's web site at www.beanclamchowder.com.

ACKNOWLEDGMENTS

Ashly, thank you for putting up with my flailing and panicking. Thanks to my brother who was always there to tell me to get my work done. And my firstborn child goes to the wonderful Krisanne McSpadden, who really deserves a co-writing credit. This book could not have existed without her.

DEDICATION

I'd like to dedicate this book to Marti Fast (I wouldn't have gotten very far without her Life Drawing Class); Elizabeth Hack; Susan Baldwin; the amazing art teachers I've had in my life; and my family and friends for supporting and loving me as the artistic hobo I am.

Table of contents

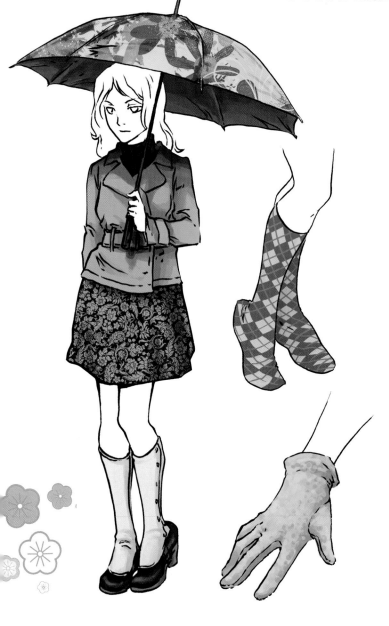

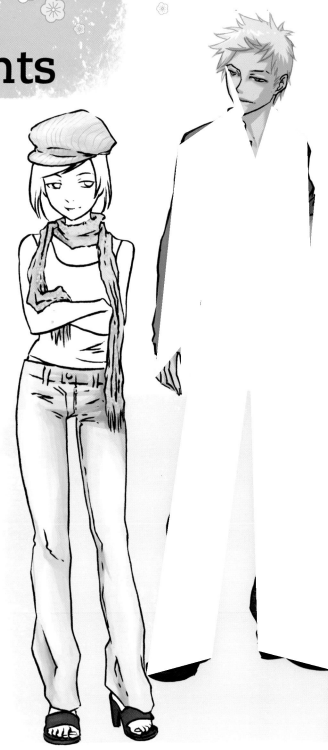

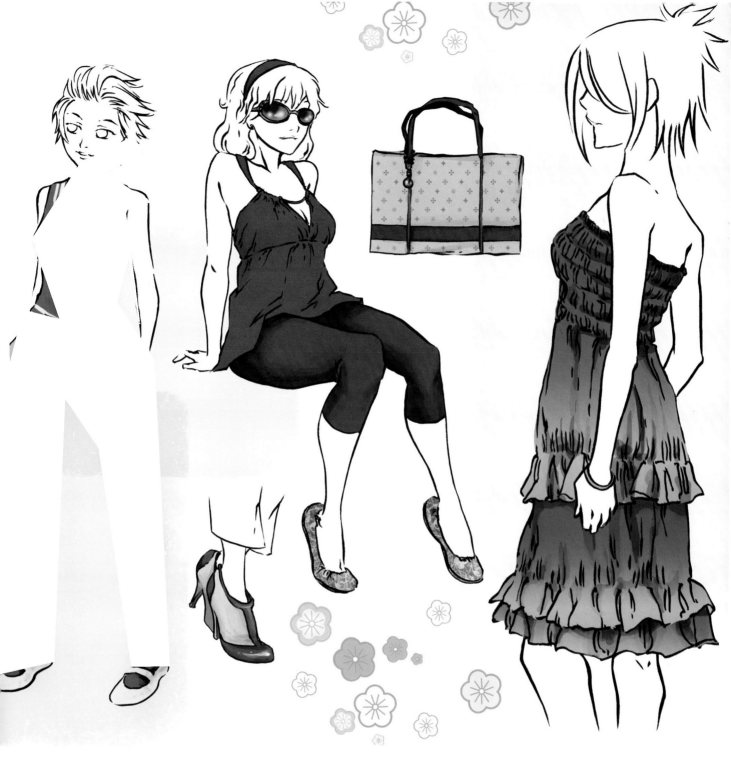

Introduction

Even though your drawing style might be heavily influenced by comic books, it has to be rooted in reality. This book provides some drawing fundamentals, with a focus on how to stylize for a manga-like look. After you have the basics, we'll move on to the fun stuff.

Clothes, like anatomy, have some fundamentals as well, certain physical nuances that affect the way they look. Understanding how they're constructed—from the seams to the cut of the garment to the textiles from which they're made—can affect how clothes appear.

After we've taken a look at how to draw realistic clothes, we can see the impact that they make when our characters are wearing them. Creating characters and drawing clothes go hand in hand. Sometimes, certain characters only have one outfit throughout an entire series. Their clothes can be a good indicator of their personality before they even utter a word.

Finally, after drawing your characters and getting them dressed, it's time to create a world to put them in. Your well-dressed characters need someplace to go, after all—be it the local hangout or their own rooms.

So turn the pages already, and get to drawing!

1 | Tools and Techniques

Walking into an art store can be a bit overwhelming. There's a wide array of options, and a lot of tools with subtle variations that can mean the difference between success and failure in your work. This section is really just a list of what I use and what I use it for, but there are many ways to go. If you're looking for a start or just some new ideas, the following pages show what I've found works for me.

Basic Equipment

The tools named here aren't absolutely necessary. As long as you have a pencil and paper, you can certainly get some drawing done. But these tools will help make the process of creating illustrations and comics easier and faster.

MECHANICAL PENCILS

Mechanical pencils are great since you don't have to keep sharpening them, and you can switch types of pencil leads. The Ohto Super Promecha is heavier near the tip. The weight allows for more control.

WHICH PENCIL LEAD TO USE?

Harder pencil leads are classified as H, while softer leads are classified as B. The harder the lead, the lighter the mark. H leads are easier to use for drawing graphic novels. The lines are lighter and they don't smudge as much as the softer B leads.

4H 3H H HB 2B

STRAIGHT EDGE

A triangle is a step up from a typical ruler. It allows for perfect ninety-degree angles, which are handy for making comic book panels.

ERASERS

A kneaded rubber eraser eliminates the mess of eraser leavings. It gets dirty very quickly though, especially if you tend to erase a lot. If you use something like a vinyl eraser, use a cheap, wide dry paintbrush to brush away the eraser leavings. It won't smudge your art like using your hand can.

PAPER

Try a variety of paper types to see which works for you. I prefer Strathmore's 300 Series Smooth Bristol board. It has a smooth surface and the thickness to handle inks and other media.

GEL PENS

The Pilot Hi-Tec-C is a refillable gel pen with various nib sizes. The ink flows smoothly, and doesn't clot, but the drying time isn't very fast. It's great for drawing the straight, crisp edges of buildings.

FELT-TIPPED PENS

Felt-tipped Pigma Micron pens also have different-sized nibs and are available at most art and craft stores. They dry quickly and the ink rarely, if ever, smudges.

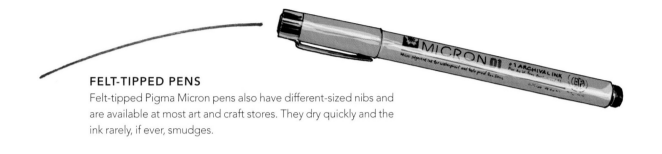

PERMANENT MARKERS

Permanent markers, such as Sharpies, are also easily found in stores. Just remember to use them in a room with good air circulation.

BRUSHPENS

A brushpen is exactly what it sounds like, an inking pen with a brush tip. Different brands have different brushes, and prices range from $13 to $60.

Brushpens can create lines of varying width, depending on how much pressure you apply while inking.

Here's another type of Kuretake brushpen with a bigger brush. It's useful for inking and filling in large areas.

Most brushpens are refillable—which is good news for your wallet. This is the Kuretake refill cartridge. The price ranges from $3 to $5 for a package of five.

Line Weight

Line weight refers to the width and thickness of line art. Adding line weight is more of a finishing step, after you've finished the initial inks on a drawing. Line variation gives an image a sense of three-dimensionality and lighting. With clothing, it can give a sense of texture, as well as showing differences in types and weights of fabric. Overall, it makes drawings look better and more finished.

A BRUSHPEN SPEEDS UP THE INKING PROCESS

Using a brushpen tends to speed up the inking process, because the outline thickness can be adjusted in one pass, as opposed to ball or felt-tipped pens, which require multiple passes.

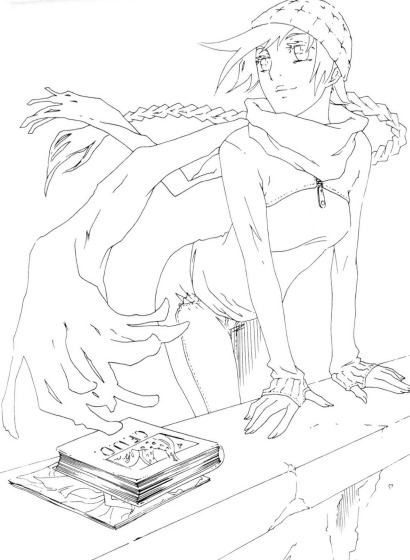

GET STARTED ADDING LINE WEIGHT
Let's start with this line art, inked with a .03 Micron pen.

ADD TEXTURE
Some well-placed lines in the hair can effectively hint at individual strands. Thick lines in the hat give it more texture and highlight the folds in the hat's tufting.

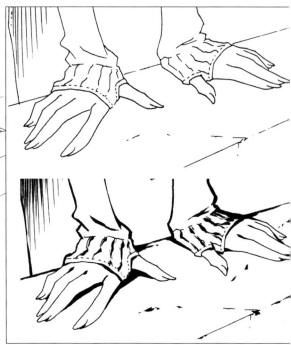

PLACE SHADOWS
The points where lines meet are a bit more pronounced. This is also the time to add shadows beneath the hand and in the deepest part of the folds in the fabric.

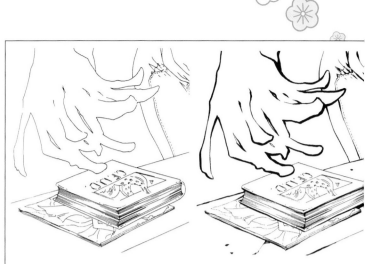

THINK ABOUT THE LIGHT SOURCE

The light source comes from above and to the left, so add more weight to the areas that should be in shadow. Rather than filling in the shadowed area on the pants with solid black, use vertical lines that gradate from thick to thin as the shadow goes from dark to light.

CREATE DEPTH

Emphasize objects in the foreground with thicker lines. This makes the fringe on the scarf much more pronounced compared with the books on the ledge.

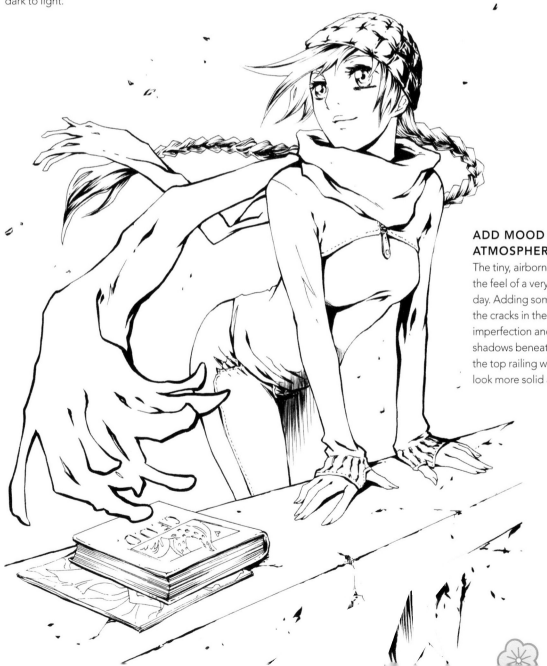

ADD MOOD AND ATMOSPHERE

The tiny, airborne flecks add to the feel of a very cold, windy day. Adding some thickness to the cracks in the ledge shows imperfection and texture. Dark shadows beneath the ledge give the top railing width and make it look more solid and cement-like.

Add Color

You could certainly leave your art black and white, but color adds that extra little bit of finish to your drawing. Color can completely change the mood of a picture. Bright, saturated colors give off a happy vibe, but desaturating and subduing those same colors makes your picture much gloomier.

Here is my process for coloring using a computer program. Although I color digitally, these same principles can be applied to traditional media.

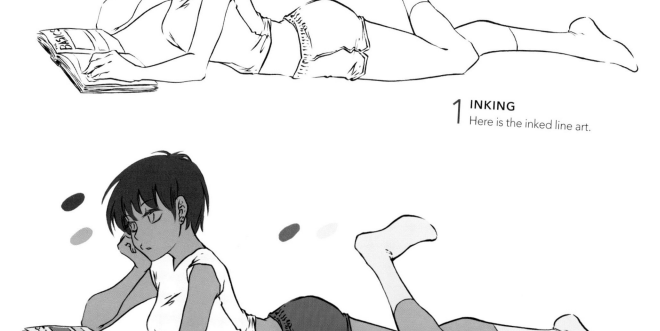

1 **INKING**
Here is the inked line art.

2 **ADD A COLOR BASE**
Choose your colors and fill in the line art, creating a flat color base.

3 CREATE DIMENSION AND INTEREST

Now choose colors for the shadowed areas—try colors that are a few shades darker than the initial flat colors.

You'll want to add a few more colors to the face to give it dimension and interest. I used a different shade for the lower lip and the skin around the eyes to give them more interest. Add color to the eyes themselves.

4 ADD FINAL DETAILS

Add a highlight to the hair, not white, but something in the same color family as the hair, only much lighter. There are also small points of white in the eyes to hint at light reflection. I added white beneath the lower lashes, too, as a stylistic coloring choice. Add clothing patterns and designs, and your drawing now has your own style.

2 | Drawing Bodies

The human figure, in all of its movements and shapes, is consistently one of the most difficult things to draw. While long-limbed, narrow-bodied characters are one of the most common types in manga, different styles can result in stouter, more muscular or more full-bodied characters.

Regardless of what your particular preference is, the best tool for drawing humans is a good understanding of human anatomy. This section is meant to give you a start in that direction. It discusses the proportions to keep in mind when drawing a character, the physical differences between the genders and provides tips for dealing with trickier body parts like hands and feet. For a more in-depth guide on drawing the human figure, look for the many books dedicated solely to the subject, or just go out and draw people!

The Difference Between Guys and Girls

A real life figure might be seven heads tall or less, but I prefer a slightly exaggerated comic book style with longer limbs.

On average, make figures approximately eight heads tall. The female figure is half a head shorter than the male, yet her height is still about eight times the length of her head.

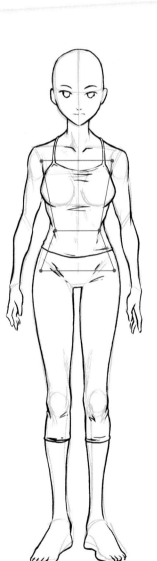

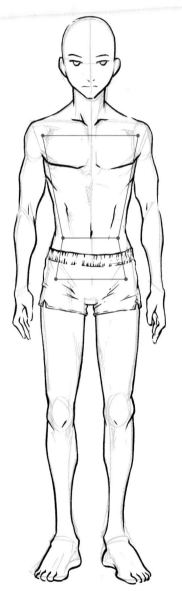

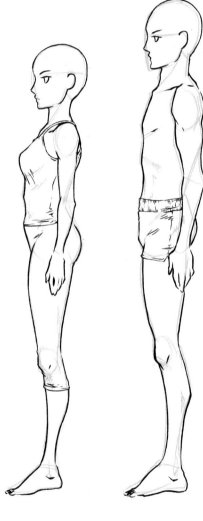

LET'S START AT THE TOP AND WORK OUR WAY DOWN

A guy's neck is thicker and his shoulders are broader than a girl's. Looking at the red lines and dots, you can see the difference in the length of the upper body and the width of the hips.

The arms on both figures are about four heads long; the elbow is almost at or slightly above the waistline, and the wrists are even with the bottom of the hips. The legs on both figures are longer than an average real-life person, but longer legs and arms are pretty common in most comic books.

PROFILES ARE TRICKIER

The halves of the body aren't identical. The torso is not a flat board that goes straight down. There are the collarbones in front, and the Adam's apple on the neck of the male figure. Then there is the difference in chest and hips. The back curves out at the shoulder blades and curves inward at the top of the gluteus.

Legs don't go straight up and down either. There is a slight S-shaped curve from the top of the leg to the ankles.

KEEP YOUR HEAD ON STRAIGHT

The neck and head are centered between the shoulders.

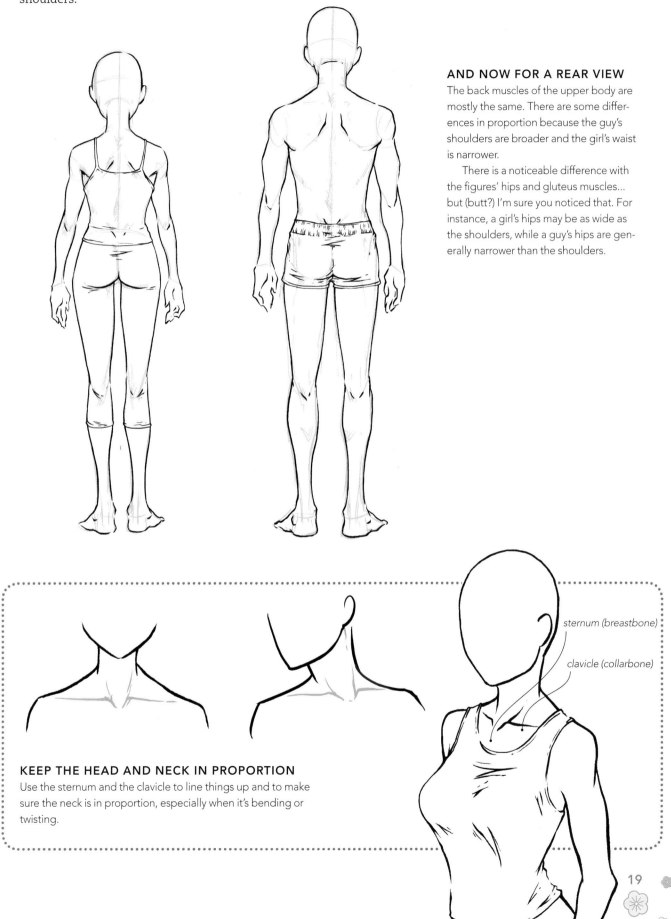

AND NOW FOR A REAR VIEW

The back muscles of the upper body are mostly the same. There are some differences in proportion because the guy's shoulders are broader and the girl's waist is narrower.

There is a noticeable difference with the figures' hips and gluteus muscles... but (butt?) I'm sure you noticed that. For instance, a girl's hips may be as wide as the shoulders, while a guy's hips are generally narrower than the shoulders.

KEEP THE HEAD AND NECK IN PROPORTION

Use the sternum and the clavicle to line things up and to make sure the neck is in proportion, especially when it's bending or twisting.

sternum (breastbone)

clavicle (collarbone)

The Arm Bone's Connected to the Shoulder Bone

When a limb moves, it affects the surrounding areas of the body. Muscles move, skin stretches and light will hit those areas differently and cast different shadows.

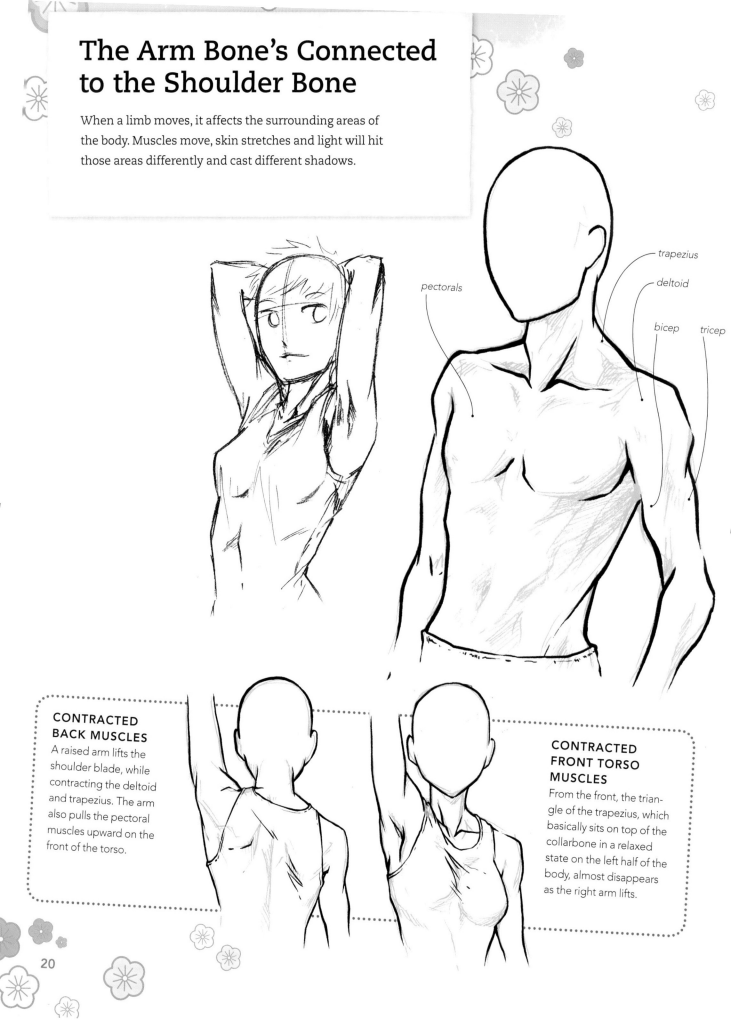

pectorals

trapezius

deltoid

bicep

tricep

CONTRACTED BACK MUSCLES
A raised arm lifts the shoulder blade, while contracting the deltoid and trapezius. The arm also pulls the pectoral muscles upward on the front of the torso.

CONTRACTED FRONT TORSO MUSCLES
From the front, the triangle of the trapezius, which basically sits on top of the collarbone in a relaxed state on the left half of the body, almost disappears as the right arm lifts.

The Leg Bone's Connected to the Knee Bone

Most manga styles portray extra-long, lovely legs, but whether your characters are short or tall, well-drawn legs convey movement, stance and attitude.

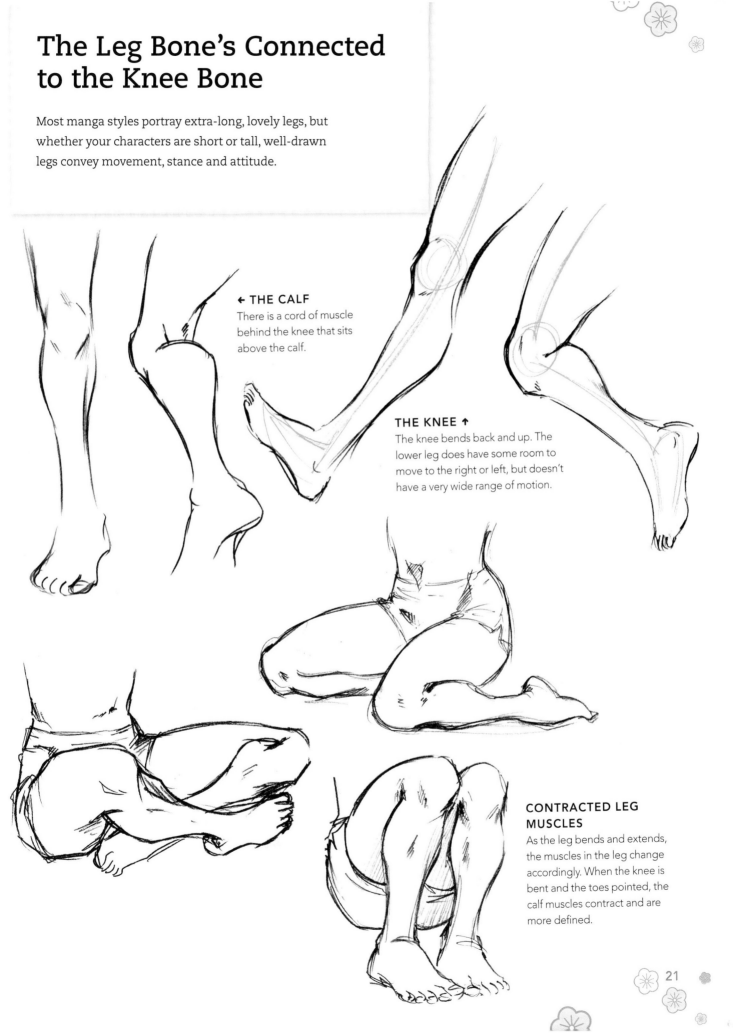

← THE CALF
There is a cord of muscle behind the knee that sits above the calf.

THE KNEE ↑
The knee bends back and up. The lower leg does have some room to move to the right or left, but doesn't have a very wide range of motion.

CONTRACTED LEG MUSCLES
As the leg bends and extends, the muscles in the leg change accordingly. When the knee is bent and the toes pointed, the calf muscles contract and are more defined.

Hands

Hands are tricky to draw since they do so many things and that results in numerous actions and positions. When in doubt, get someone to pose and take reference pictures of their hands. That's what friends are for.

A HAND'S BASIC SHAPE

The basic shape of the back of the hand is square—widening from the wrist to the knuckles. The line beneath the knuckles curves slightly.

brain line

heart line

THE IMPORTANCE OF KNUCKLES

Fingers are split in three sections under each knuckle, which bends. Typically the fingers get wider at that second knuckle, and then taper off at the last one into the fingertip.

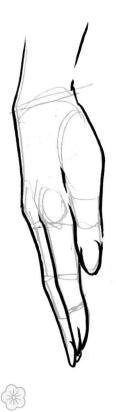

WHAT DOES A PALM REALLY SAY ABOUT US?

Spread out, the fingers of the hand should pretty much connect to a point at the wrist. The main features of the palm are the thumb group in yellow, the pinky group in well, pink, and the pads under the knuckles. You don't have to draw a lot of lines and ridges on the palm. Generally, just the heart and brain lines are enough, since they are very prominent.

THE OPPOSABLE THUMB

The thumb only has two knuckles and bends in one place.

Have Fun Drawing Hands in All Different Positions

Use yourself or a friend as a hand model. Draw hands doing every sort of gesture. This will help you become familiar with how they work and move and how you can use hands to your character's benefit.

Feet

Feet, like hands, can be tricky to master, but don't try to keep them out of panel just to avoid doing the work! Well-drawn feet and their movements are signs of a capable artist. Here are some diagrams to help you.

THE FIVE LITTLE PIGGIES
Each toe has a different shape and they generally look like this. The big toe can be longer or shorter than the second toe.

A FOOT'S BASIC SHAPE
Draw the bottom arch of the foot as if it's not touching the ground. It actually does, but the emphasis of the arch makes the foot look more defined.

REMEMBER THE HI-LO RULE
When it comes to ankle-bones, remember the HI-LO rule: high inside, low outside. The ankle on the inside of the foot is higher than the bone on the outer side of the foot. And when it comes to the tendons in the foot, the big toe has a separate cord, while the other four join together.

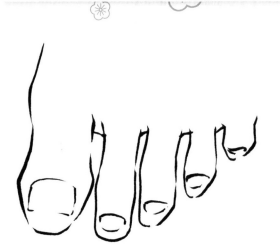

THE SOLE OF THE FOOT
The highlighted areas of the foot protrude the most, and the white areas sometimes don't touch the ground at all.

Have Fun Drawing Feet in All Different Positions

Use yourself or a friend as a foot model. Draw feet in many different positions and from different angles. This will help you become familiar with how they work and move and how you can use feet to your character's benefit.

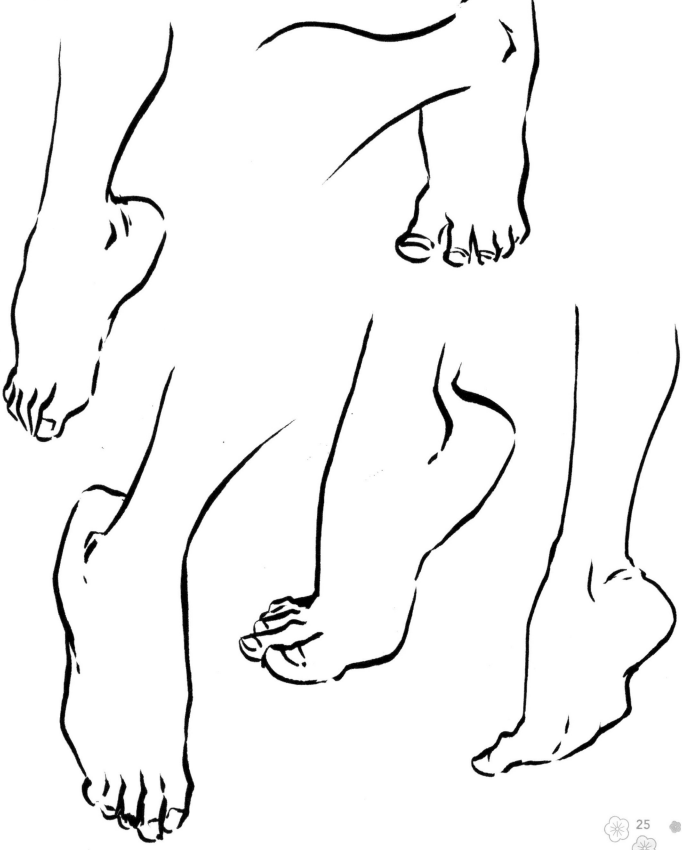

Drawing From the Inside Out

It's hard to draw a figure without a basic sketch.

START WITH A "SKELETAL" STRUCTURE

The skeleton can be simple line gestures of the direction of the spine, limbs, shoulders and hips. Use that skeleton to guide the structure of the body.

FILL IN THE SKELETON

Adjust the pose so that it works with the actual proportions of the human figure.

Body Types

Using basic skeletal structures and the anatomy tips you've learned so far in this chapter, try drawing different body types.

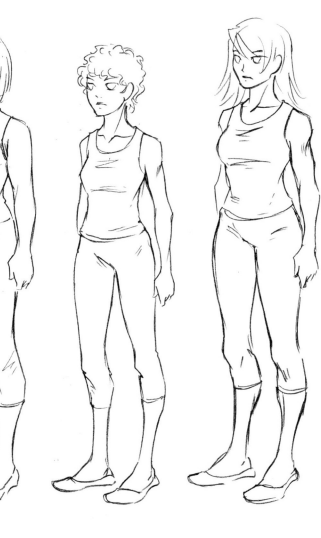

AVERAGE BODY TYPE

STOCKY BODY TYPE
Stocky bodies have thicker ankles, the deltoids and other muscles are not as pronounced and the neck is wider.

PETITE BODY TYPE
Petite and thin body types have more definition when it comes to bones/ muscles/tendons.

MUSCULAR BODY TYPE
With tall, muscular builds, make sure to define those muscles!

Putting People in Poses

Refer to the section on skeletal structure (page 26), and you'll find the process for creating different poses is basically the same.

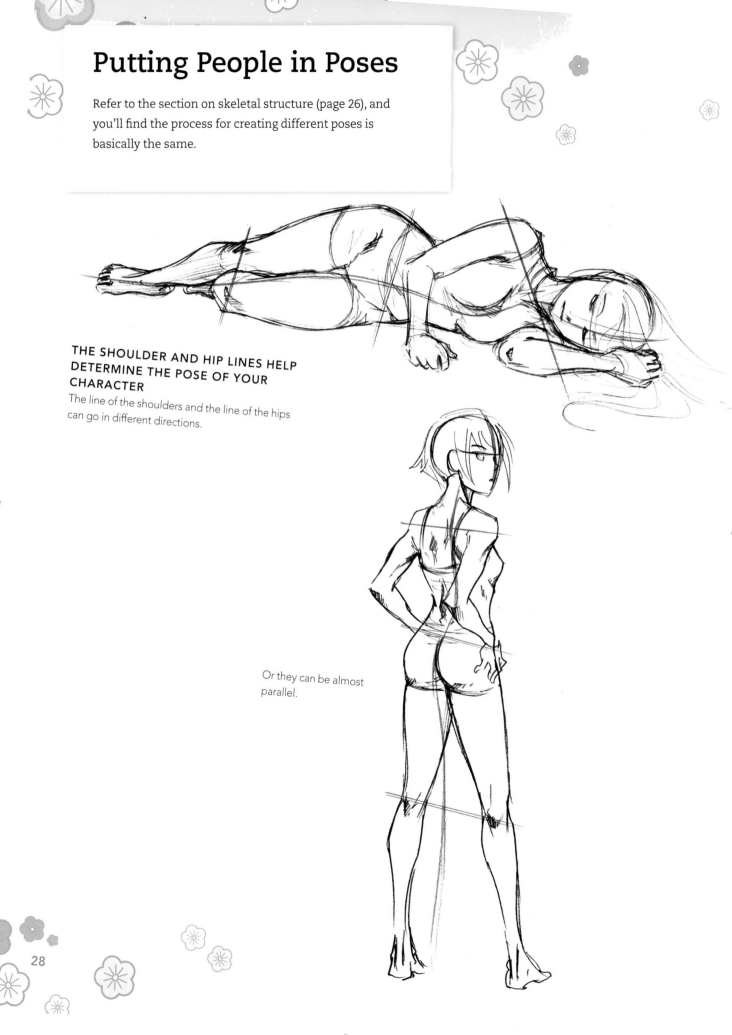

THE SHOULDER AND HIP LINES HELP DETERMINE THE POSE OF YOUR CHARACTER

The line of the shoulders and the line of the hips can go in different directions.

Or they can be almost parallel.

STANDING POSES

Whether standing still or walking, the leg holding up most of the figure's weight is more defined because more muscles are being engaged.

SEATED POSES

When a figure sits down, the gluteus and the thighs flatten out on the surface of whatever the figure is sitting on. It may seem a little strange at first to draw almost flat lines where things are normally curved, but showing the interaction between the body and objects makes the setup believable.

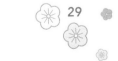

Action Poses

Being able to draw action, even in a story with no combat at all, is a necessary part of any manga. Action can be anything from walking to performing a long lost, secret guardian samurai technique.

Action poses should look like natural movement is occurring, not like limbs are haphazardly cast in dramatic directions. When people move, their bodies have a natural flow, and this is how even an unruly sport or dangerous fight scene can have grace.

GRACE AND POISE

A ballerina has a lot of grace and poise. Her limbs are stretched out and the muscles in her calves are defined. It takes a lot of effort to dance en pointe.

LUNGING

The muscles in the legs and arms are defined as this volleyball player lunges for the ball. The movement of the hair helps to give a better sense of the speed of action.

RUNNING

When running or walking, the movement of the arms and legs are in opposition. If the left leg goes forward, the left arm goes back. As the right leg moves forward, the right arm moves back.

FIGHTING STANCE

She's looking right, her upper body is twisting left and her legs are in a squatting position reminiscent of a martial arts horse stance. It's not the most comfortable or practical pre-fight pose, but it looks very dynamic.

JUMPING

When jumping from something tall, the pectoral muscles pull upward as the arms raise. This character is also looking downward, which, from this angle, makes his neck look shorter.

FREESTYLE

All the weight is on this b-boy's right arm as he performs this freeze. The left side of his torso gets squeezed in as he brings his leg outward, so the muscles of his stomach are more compressed on that side of his body.

Putting Your Poses in Perspective

When bodies are drawn from different angles, certain parts of the body appear larger in the foreground. That's called foreshortening. And when those foreshortened body parts are exaggerated, that's forced perspective. The latter is used a lot in graphic novels, to make poses and actions more dynamic.

BIRD'S-EYE VIEW

This angle is drawn from above and gives the body a funnel-down effect. In this example, I'm using guidelines that connect to a single point to help define the body's shape.

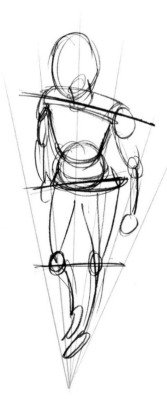

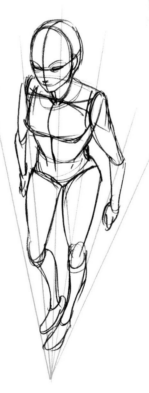

1 DRAW THE SKELETON
Rather than straight lines, use curves for the shoulders and hips. These curves primarily angle downward.

2 FLESH OUT THE FIGURE
Begin making the skeleton a properly proportioned figure.

3 REFINE THE FIGURE
The shoulders are a bit broader than average, but it really emphasizes the angle. The trick is drawing the body in what looks like proper proportion, so it doesn't look like you drew a figure with a freakishly big torso and tiny legs.

WORM'S-EYE VIEW

Flip the guidelines 180 degrees to draw a person seen from a very low angle. It's pretty much the opposite of the bird's eye view.

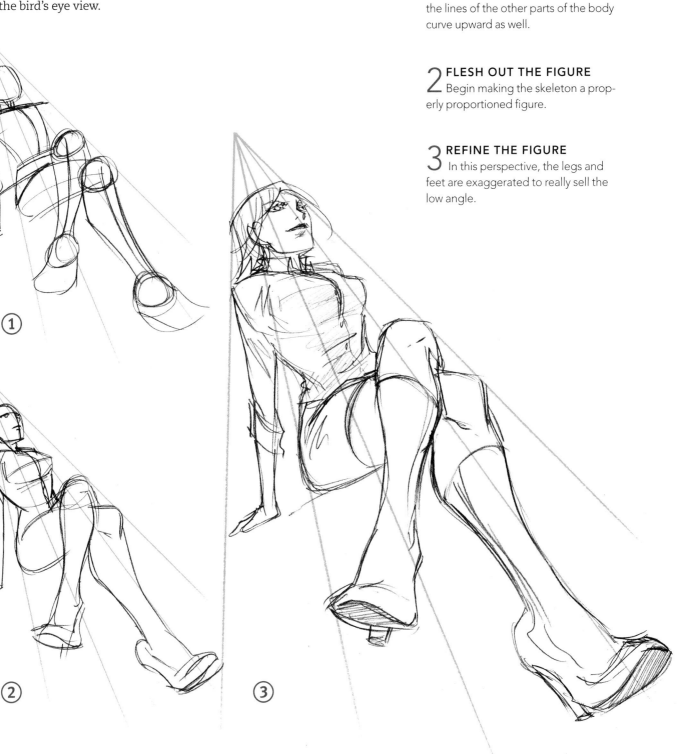

1 DRAW THE SKELETON
This time, the lines of the shoulders and hips curve upward. Based on that, the lines of the other parts of the body curve upward as well.

2 FLESH OUT THE FIGURE
Begin making the skeleton a properly proportioned figure.

3 REFINE THE FIGURE
In this perspective, the legs and feet are exaggerated to really sell the low angle.

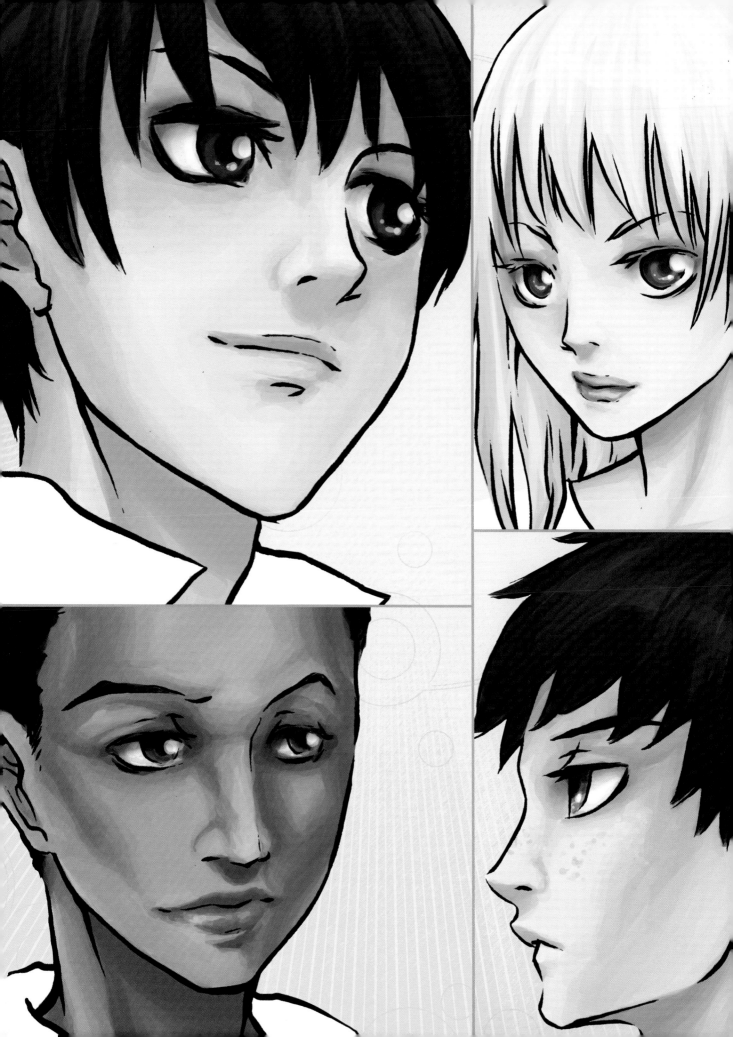

3 | Drawing Heads and Faces

This section covers what is perhaps the most heavily recognized facet of manga-style art: big eyes, expressive faces and simple features. If you've opened this book, this is probably part of why you are here. Manga-style facial art is not intended to be realistic. In fact, many of the pro-portions are intentionally skewed, and chances are if you met someone in real life with huge eyeballs and magenta hair, you would be a little unnerved! But in comics, enlarging and elongat-ing certain features, like the eyes, lips and neck adds an attractive accent to the art and character designs.

Within this section you will find simple instructions on how to create a basic head, but from there it's up to you to make each face unique. You'll also get help with drawing heads from different angles, and a nifty little guide showing a gradient of expression. Practice all of these thoroughly, as faces and expressions are key to a unique and memorable character design. And once you have it down, don't be afraid to change up the details; there is no ironclad rule as to what makes something manga-styled, and it's those little variations that give each artist her own style.

Basic Structure

It might seem like faces can be different in only so many ways, what with everyone having the same basic features. But in reality, each person's face is unique and subtly or obviously different from the next person's. Keeping this in mind as you determine everything from the shape of your character's head to the width of their lips and the height of their cheekbones is what will help you create an individual look that your readers will be able recognize from the face alone.

DRAW THE FACE HEAD ON

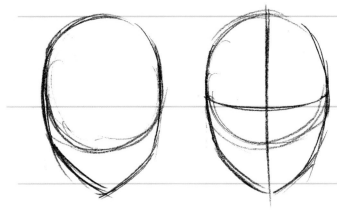

1 START WITH A CIRCLE AND ADD THE JAWLINE

Things like the jawline and chin can always be adjusted later on, so the sketch doesn't have to be perfect.

2 DRAW A VERTICAL LINE THAT SPLITS THE FACE IN HALF

Then add a horizontal line, about a third of the way down the circle, which will help you line up the eyes and ears.

3 ADD THE FACIAL FEATURES

Start with the eyes by aligning the top lid with the horizontal line. On average, the space between the eyes is another eye length, but it definitely shrinks with the tendency to make eyes larger in manga. Now you can erase the bottom part of the circle, and the curves left behind act as guides for the cheekbones.

4 FINISH ADDING THE FEATURES

Nose length tends to vary with face shape, but on average the nose ends on the lower third of the face. Mouth location varies too, so place it where it best fits the character. A lower mouth drags the face down and ages a character. It makes them look a bit sour, too.

DRAW THE FACE IN PROFILE

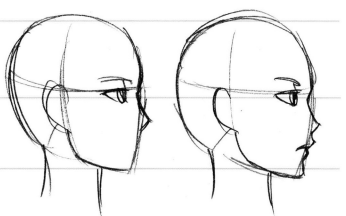

1 A PROFILE VIEW STARTS WITH A CIRCLE
The basic shape resembles the straight-ahead view, but now the jaw line is off to the side.

2 ADD THE GUIDE LINES
The off-center vertical line curves down into the jaw and the addition of the horizontal line once again lines up the eyes and ears.

3 ADD THE FACIAL FEATURES
The brow bone protrudes to a point above the eye and then dips in to the base of the nose bridge. It then slants downward to form the nose.

4 FINISH ADDING THE FEATURES
The mouth and chin can vary greatly with different characters, so take note of the basic structure and play with the proportions.

DRAW THE FACE IN A TWO-THIRDS VIEW

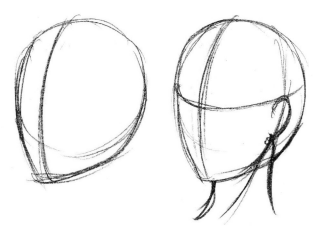

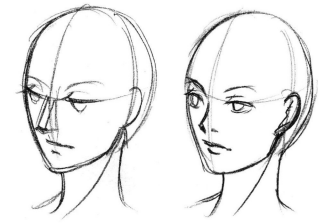

1 A TWO-THIRDS VIEW GETS A BIT TRICKY
It starts out with almost the same template as the profile view, but now the vertical line that divides the face curves in the direction the character is facing.

2 ADD A HORIZONTAL LINE HALFWAY THROUGH THE CIRCLE
Then sketch the ear, starting at the intersection of the horizontal and vertical lines. This gives a better sense of where other features will go on the face.

3 ADD THE FACIAL FEATURES
The top lids of the eyes should follow the horizontal line, and the eye on the right side of the face needs to be a bit smaller. The nose is a very angular shape to show how the angle affects it. Refine the shape into an actual nose.

4 REFINE THE FEATURES
A two-thirds view of the face is somewhere between a straight-ahead and a profile. So think about the facial features and their three-dimensionality.

Change the View

By simply changing the angles of your basic facial guidelines, you can draw the face from many different perspectives.

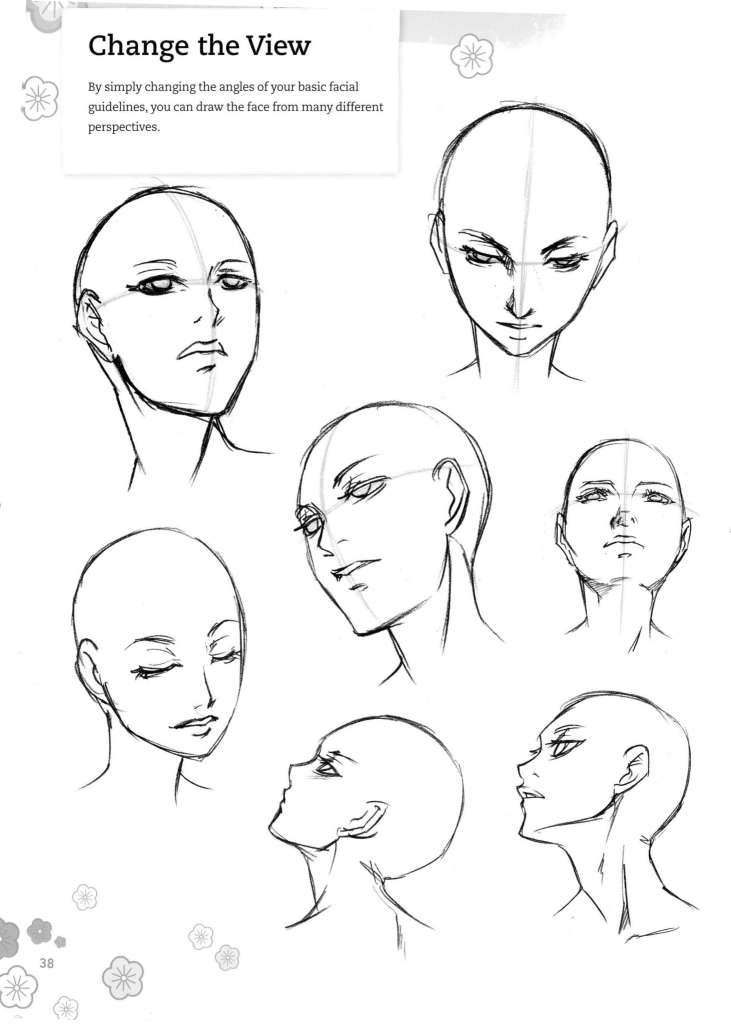

Other Structural Considerations

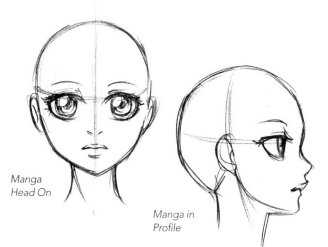

Manga Head On

Manga in Profile

EXAGGERATION

In manga, facial features and expressions tend to be exaggerated, so the rules of proportion shift slightly to accommodate style.

When you make an eye wider, leave roughly twice as much space between both eyes as there is between the eye and the edge of the face. For making the eyes taller, take space away from the cheeks; the upper lid stays lined up with the horizontal guideline of the face. This makes the face look like it's still in proportion, even with the large eyes.

The large eyes used in manga also affect the profile view of the face. The brow bone is stretched out and the nose bridge gets shorter.

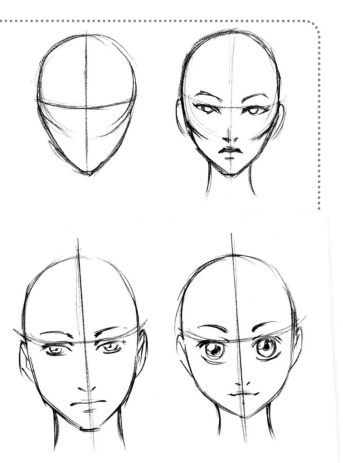

ANYTHING GOES!

Now that you know the basic facial structure, you can create unique features. Draw a stronger jaw, sharp eyes, thin lips or round cheeks. The possibilities are endless.

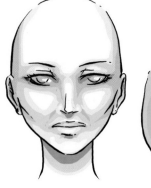

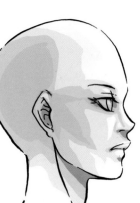

LIGHTING

The varying shades of blue show the shadows and highlights as a light source washes over the face. If the light intensifies, the lighter colored areas will be washed out and the shadowed areas will recede.

BOY VS. GIRL FACES

With a generic male face (above left), the jaw is more defined and the chin is wider and flatter. The face is slightly longer than a female face (above right), with a longer nose. A younger male can have a softer facial structure like a female character though. Details like thinner lips and shortening or leaving off the eyelashes will make him look more like a boy.

Eye Shape and Structure

Eyes are one of the most important features of a character. It's pretty impressive when you see an extreme close up of eyes and can instantly tell which character it is.

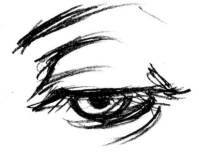

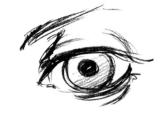

THE EYE'S BASIC SHAPE

The eyeball is basically a sphere. The lash lines of the eyelids touch the iris. The eyeball bulges a bit, so add some definition to the eyelid to hint at the eye's spherical shape.

CLOSED EYES

When drawing a closed eye, let the lids follow the shape of the eye.

DRAW THE SPHERE IN PROFILE

1 **CREATE THE BASIC SPHERE**
Add the iris.

2 **DRAW THE TOP AND BOTTOM LID**
The lids join together to form a triangular shape. This clearly shows that the eye protrudes outward.

3 **ADD LASHES AND THE EYEBROW**

DRAW AN EYE STRAIGHT ON

In manga art, the eye doesn't necessarily have to start with that basic sphere. The way you draw eyes is a stylistic choice, but the following steps can be applied to whatever eye shape you end up choosing.

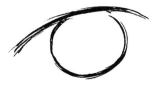

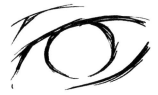

1 **START WITH THE LASH LINE AND IRIS**
The iris and lash line should touch.

2 **DEVELOP THE SHAPE**
Add another line for the bottom of the eye, and the crease on the top eyelid.

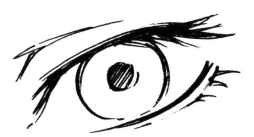

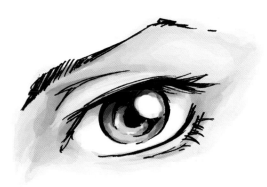

3 **START THE DETAILS**
The lash line gets a little darker, because it's naturally shadowed. Add wisps of lashes.

4 **DEVELOP THE DETAILS**
Draw the eyebrow, figure out the direction of the light source and add a spot of reflected light. The highlight obscures some of the pupil. For emphasis, darken the area immediately around that highlight spot. The broken circle around the pupil hints at the slight color difference that shows the form of the iris.

DRAW A SIMPLIFIED AND STYLIZED MANGA EYE IN PROFILE

1 **CREATE THE BASIC SHAPE**
Start with the shape of the eyelids and the visible part of the eyeball. In this case, it's triangular.

2 **ADD LASHES AND THE IRIS**

3 **DRAW SOME DEFINITION**
Darken lashes and add a few lines to hint at the eyelid creases.

4 **COMPLETE THE EYE**
The eyebrow and pupil finish it off.

Give Your Eyes Personality

Different kinds of eyes project different characteristics. Large, open eyes can seem kind and innocent. Half-lidded or sharper eyes are secretive or sly, even vicious—perfect for villains.

Play around and create droopy eyes, eyes with small pupils and slitted pupils. Heck, while you're at it, feel free to give a character three pupils that look like commas and spin around.

Eyebrows are also an important tool and are very effective in showing a character's personality.

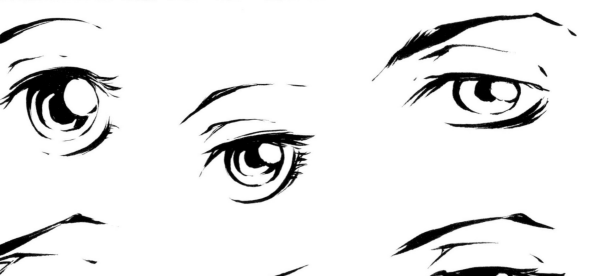

MALE EYES

Eyes are pretty interchangeable between the genders. Generic male eyes, however, have no long eyelashes and the eyebrows are slightly thicker.

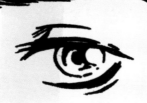

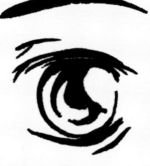

PRACTICE DRAWING EYES FROM DIFFERENT ANGLES

Your characters' eyes will have different shapes depending on perspective—a bird's-eye view may tend to narrow the eyes, while a view from below might show more of the round eye shape.

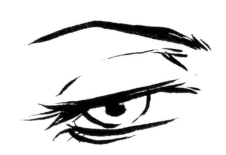

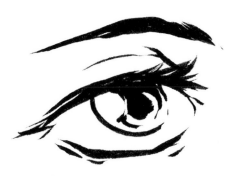

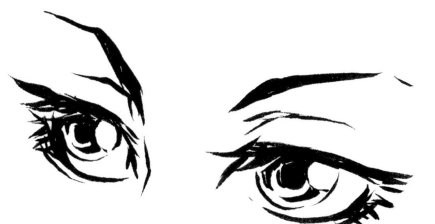

Mouths

The mouth can be left as a simple line, or it can be highlighted by tones or inked. The lips can be small, full, smiling, always scowling, thin or even falling off. The latter refers to zombies, of course... mostly.

DRAW THE MOUTH STRAIGHT ON

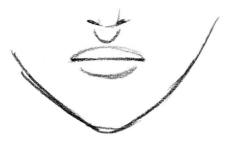 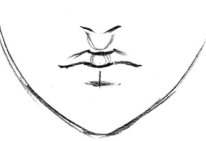 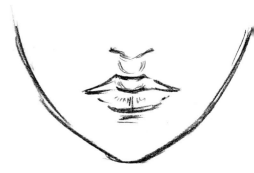

1 CREATE THE BASIC SHAPE
Start with the very basic shape of the lips.

2 DEVELOP THE SHAPE
There is a dip in the center of the upper lip which follows the dip beneath the nose. The corners of the lips also turn upward.

3 ADD THE DETAILS
Add as much detail as you prefer. Outline the lips, add the small lines that appear on the lips and add the gap between the lower lip and chin.

DRAW THE MOUTH IN PROFILE

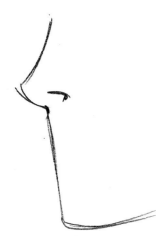 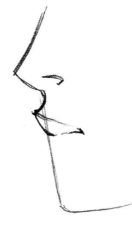

1 CREATE THE BASIC SHAPE
Let's start with this nice flat surface beneath the nose.

2 DEVELOP THE SHAPE
The dip beneath the nose curves out and then curves back in to form the upper lip.

3 ADD DEFINING DETAILS
The bottom lip curves out again and then goes down to the chin.

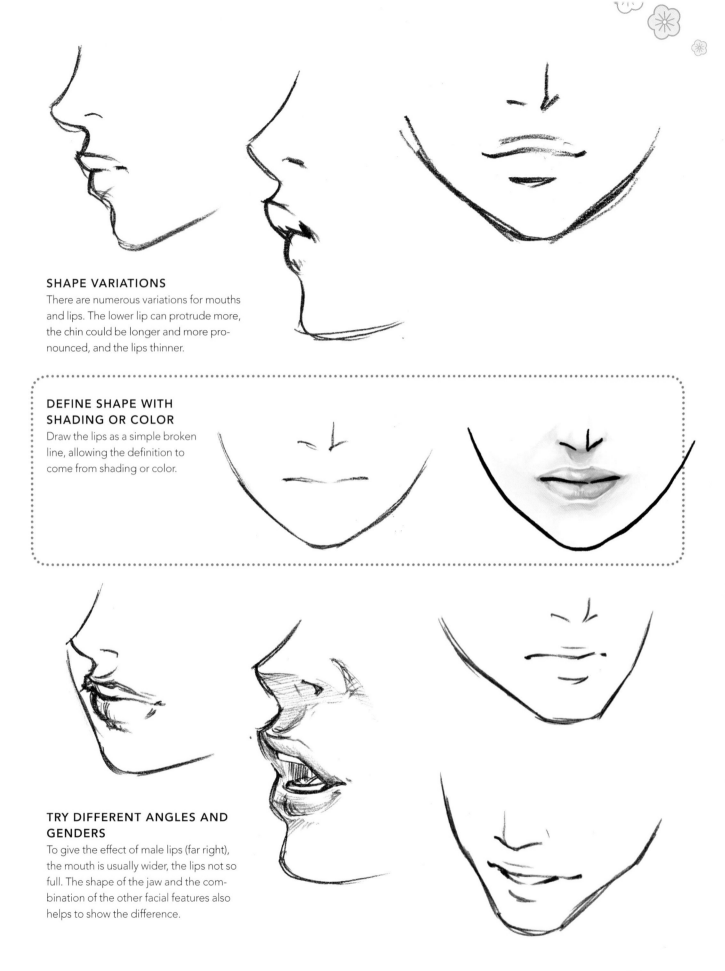

SHAPE VARIATIONS

There are numerous variations for mouths and lips. The lower lip can protrude more, the chin could be longer and more pronounced, and the lips thinner.

DEFINE SHAPE WITH SHADING OR COLOR

Draw the lips as a simple broken line, allowing the definition to come from shading or color.

TRY DIFFERENT ANGLES AND GENDERS

To give the effect of male lips (far right), the mouth is usually wider, the lips not so full. The shape of the jaw and the combination of the other facial features also helps to show the difference.

Noses

A nose is a feature that can add a lot of character to a face. Noses can be big, small, flat, hooked, broken, bulbous, or simply ugly or attractive. Keep in mind that the more lines on your characters' faces, the older they will look. In manga, noses tend to be discrete, sometimes no more than a couple of nostrils. But that's up to you.

NOSE LENGTH
Determine the length of the nose. A circle shapes the tip of the nose so draw it as large or small as you want.

THE NOSTRILS' BASIC SHAPE
The nostrils flare out from the sides of the circle. These vary in size as well.

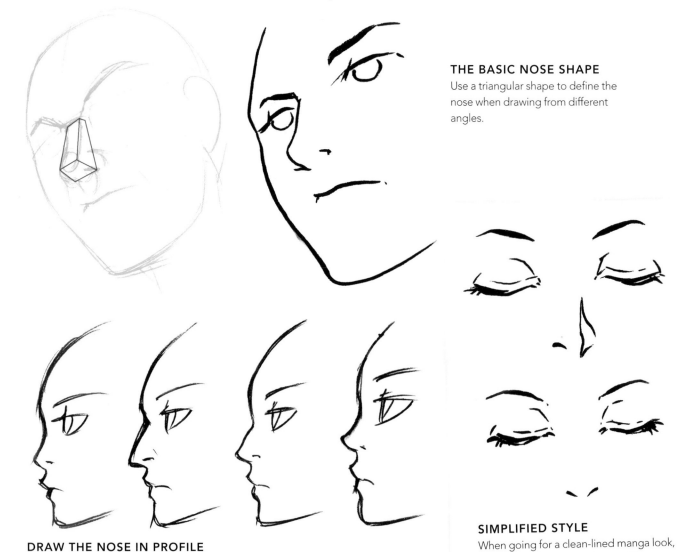

THE BASIC NOSE SHAPE
Use a triangular shape to define the nose when drawing from different angles.

DRAW THE NOSE IN PROFILE
The easiest way to draw the profile of a nose is a line for the nose bridge from under the brow bone and curving back in. However, there are also a number of ways to make noses look different. Nostrils might be larger, the nose bridge wider, or it might have a bump on the bridge or a hooked tip.

SIMPLIFIED STYLE
When going for a clean-lined manga look, you can keep it simple. Two small lines to represent the nostrils are all you need for a nose. A very simplified shadow on the side of the nose works too.

Ears

Like the other parts of the face, the ears can be simplified, so don't get bogged down in the details of every fold and bump.

DRAW A BASIC EAR

1 CREATE THE BASIC SHAPE
This ear is drawn in profile.

2 DEVELOP THE SHAPE
Draw part of the upper cartilage of the ear, leading down to the small bump called the tragus.

3 START REFINING
Another line finishes off the lower lobe. This line should look like it connects to the upper cartilage, but leave the line partly broken.

4 DEVELOP THE DETAILS
A few short curves are enough to represent the inner folds of the ear.

THE EAR, STRAIGHT ON
Ears from a straight-ahead view usually just consist of part of the upper lobe and tragus, but some peoples' ears tend to stick out more.

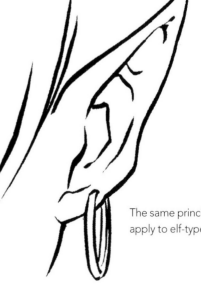

The same principles apply to elf-type ears.

Facial Expressions

Expression, both the subtleties and extremes, are a huge part of any manga. Entire books could be, and have been, dedicated to the movements and emotions of the face alone. Studying people around you, as well as other manga, will be your greatest help in learning to draw various expressions. But to get you started, a number of emotions with varying degrees of intensity are shown here. Sometimes, all it takes is the set of the eyebrow or a quirk of the mouth to get a feeling across. Sometimes it takes full-on yelling and crocodile tears.

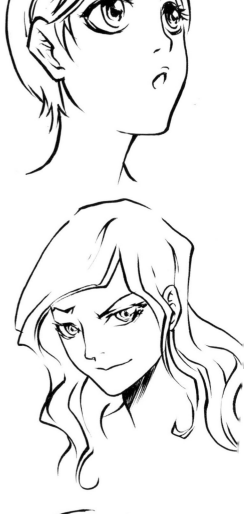

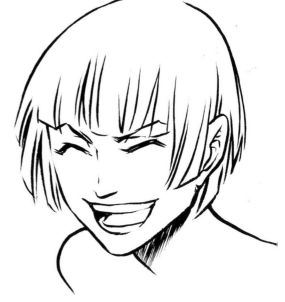

DRAW THE MANY FACES OF YOUR CHARACTER

Practice facial expressions with a single character to gain experience with character consistency. Use several angles so it doesn't get boring.

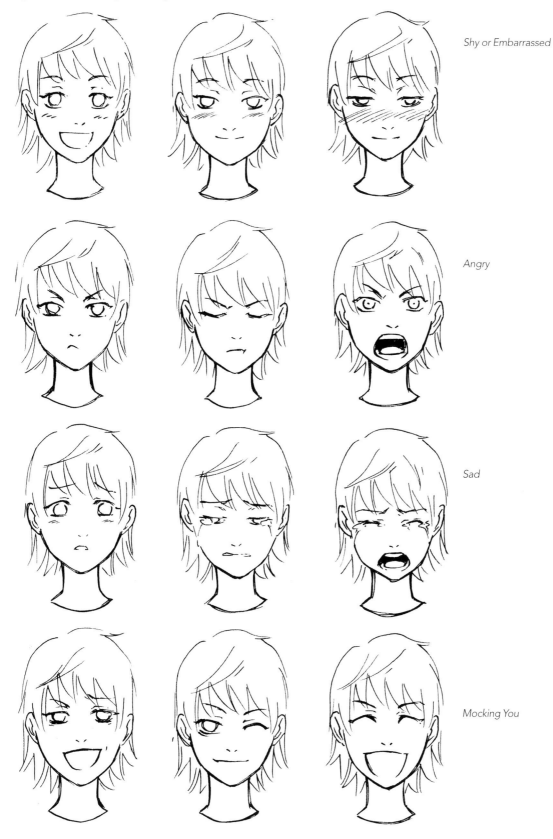

Shy or Embarrassed

Angry

Sad

Mocking You

Add Hair—The Icing on the Cake!

You can have a lot of fun with the style and color of a character's hair. It can be long and wavy, gravity-defying spiky, blond, purple, white or gray.

The following pages show a few examples of the numerous hairstyles out there. Rather then taking it step by step, I'll share some basic techniques that you can build on to draw all sorts of hairstyles.

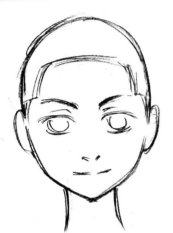
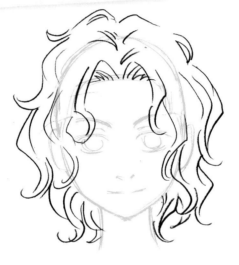
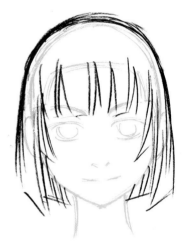

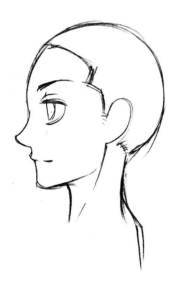
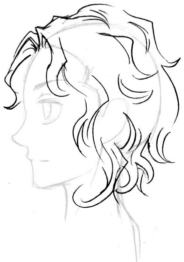
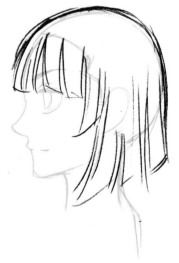

ESTABLISH THE HAIRLINE

Establish the hairline on the scalp. Forehead size varies and the average is between the top of the head and the top of the eyebrows.

START WITH THE BASIC HALO OF HAIR

Do this by following the curve of the head. Hair should rise above the scalp to show some thickness. Keep your pencil strokes long and smooth. Short strokes give the hair a fuzzy look, which is fine if you're drawing short, fluffy hair, but for long, smooth hair, keep the pencil strokes long and loose.

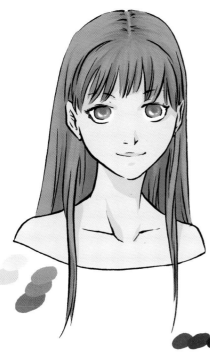

Hair Color

The following examples show naturally occurring color variety, although more saturated than what you'd see in real life.

REDHEADS

The color palette for redheads includes auburn, red, orange and everything in between. In a manga setting, red hair is often represented with a light gray tone, something with a fine grain.

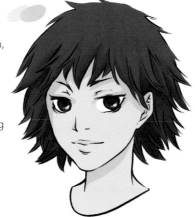

BLOND HAIR

Blond hair can be straight up gold, have tinges of red or brown or can be very light and pale. In manga, characters with light-colored blond hair are usually lightly inked, with little to no tones.

BROWN AND BLACK HAIR

Brown or black hair is a little easier to deal with, although there are still quite a few tone variations from light brown to black. In manga, brunettes and black-haired characters get darker tones, or can just be inked without using any tones.

Long Hair

Long hair isn't all completely even, and doesn't flow neatly down a person's back. Long hair drapes and falls over the shoulders, and if hair has a bit more volume or wave, it makes its own shape as it flows.

DRAW A SIMPLE BRAID

1 CREATE THE BASIC SHAPE
Start with a wide base that tapers down to the end of the braid. Draw a bunch of V shapes, but let the lines on one side of the braid overlap the other lines.

2 DEVELOP THE SHAPE
Draw the lines all the way to the base of the braid. The space between the lines decreases as you get closer to the end.

3 REFINE THE SHAPE
Round out the outside lines. Each space is a mass of hair getting tucked into the facing group.

4 DEVELOP THE DETAILS
The areas where the hair weaves in the middle get more shadow. The strands of the hair follow the direction of each braid section.

INK IN LONG HAIR

1 INK THE INITIAL SHAPE

For black and white shading, ink the initial shape of the hair.

For characters with lighter hair, such as blonds, stop inking at this stage, adding some lines in the shadowed areas to give those areas more definition, but for the most part, leaving a lot of white space.

2 ESTABLISH DEPTH

Make the ends of the bangs and the bottom of the clumps of hair darker, letting the line fade as it goes up. This hints at individual strands of hair, as well as the reflection of light.

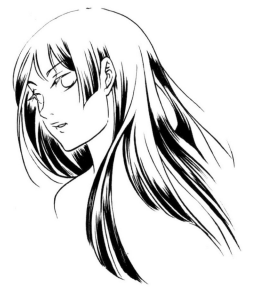

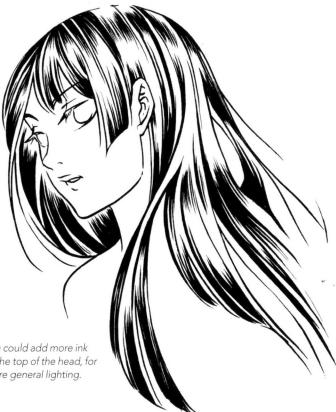

3 DEVELOP SHADOWS

The hair on the right side of her face is inked more heavily, since it's in shadow. But the area around her face is haloed so that the ink doesn't interfere with the line weight detail on her face. On the left side of her face, add more ink to the shadowy parts, and the dips in the waves of hair. This could be a finished example, if the light source for this drawing was particularly bright.

You could add more ink to the top of the head, for more general lighting.

Short Hair

Short hair is really versatile and fun to draw. It can be really short and close to the scalp, slightly longer and spiky, smooth and orderly, styled or in complete disarray.

CLOSE-CROPPED HAIR

Use short, abrupt strokes to give the effect of close-cropped hair.

MESSY HAIR

Create bands of white that overlap each other in different lengths and directions.

To create the look of messy dark hair, make the bands of white very minimal. Break them up often with a lot of black to give the illusion of a lot of strands of hair that stand out rather than being sleek and flat.

SIMPLE WAVY HAIR

Draw the outline of the hair. A couple of these line groups will give the effect of soft waves in the hair.

Draw a longer wave and smaller waves emanating from it, following its shape.

TRY DIFFERENT STYLES

Have fun with your character's hair; hairstyle and
personality go hand in hand.

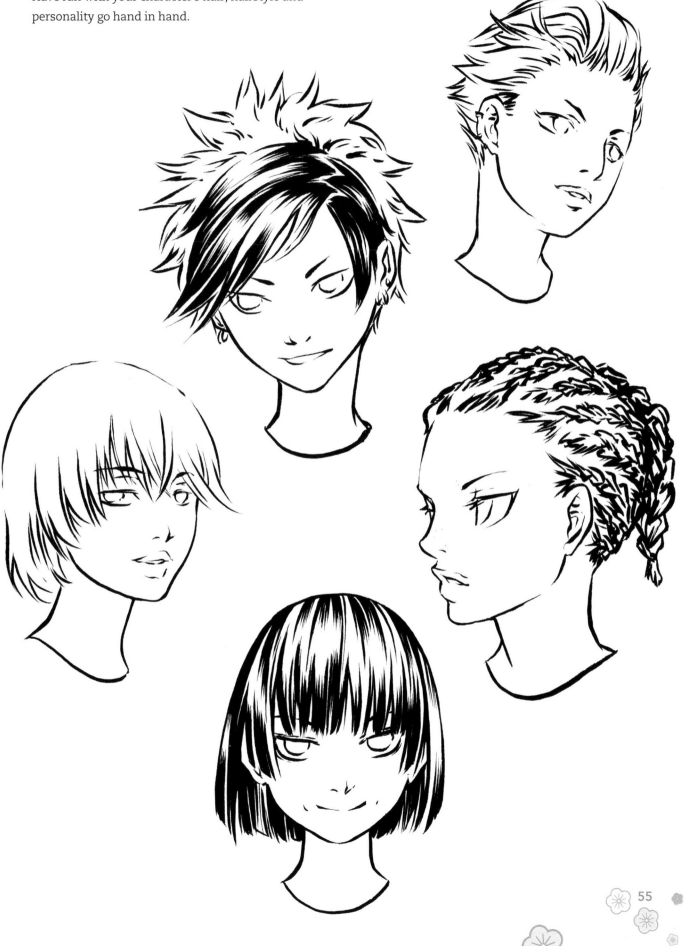

Hair Tied Back

To draw tied-back hair, just make the direction of the strands consistent. If someone has bangs, there should be a spot where that division happens. The hair flows to the spot where the hair is tied. The hair will drape a bit more if it is tied loosely.

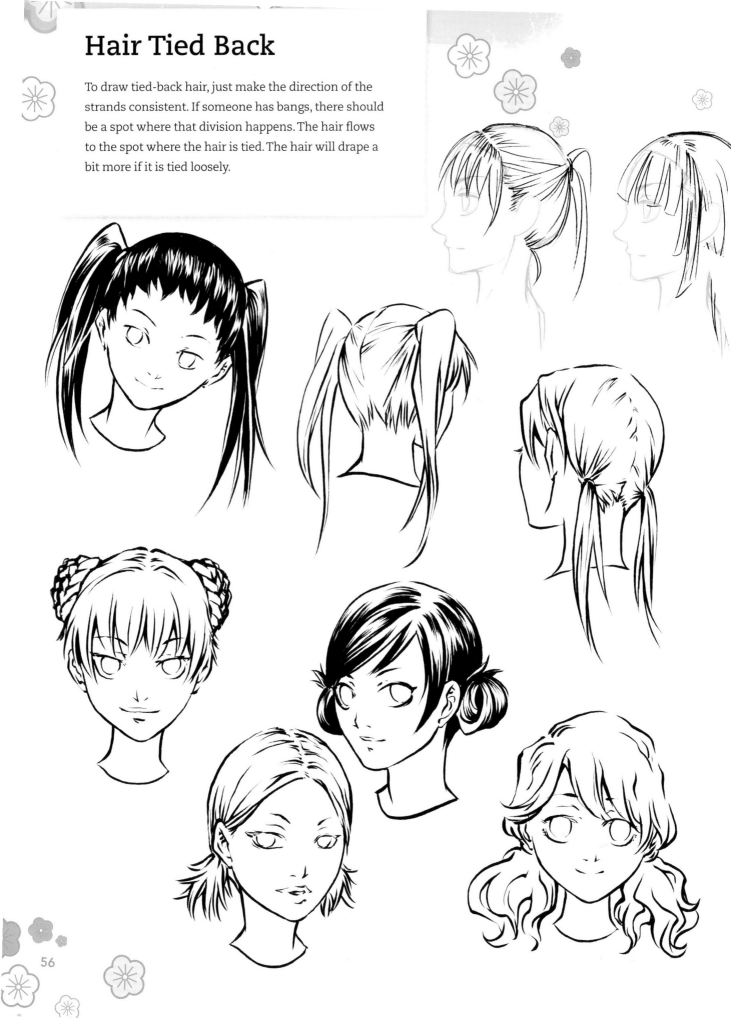

Curly and Wavy

This can get a bit tricky. Curls and waves need to look random, but still have some order, or the hair will just look like a big mess. Try not to draw individual strands, but, instead, draw larger clumps of waves and curls for a cleaner look.

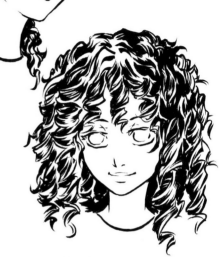

DRAW A RINGLET

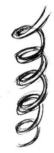

1 CREATE THE BASIC SHAPE
Draw a spiral, like a phone cord. You can probably find a phone with a cord in an antique store. Or museum. Or on the Internet.

2 DEVELOP THE SHAPE
Make the sections thicker. At this point, you'd barely be able to see the back half. The hair tapers off at the bottom, so thin down the width as it reaches the tip of the curl.

3 REFINE THE SHAPE
The strands of hair follow that spiral motion. Leave the outside edges with slight bumps and imperfections to show some separation between the hair.

4 DRAW A BUNCH TOGETHER
To create a full head of hair, draw many ringlets close together.

Ringlets are definitely not uniform. They can be loose or tight, and if they are a light color, cut down on the amount of shadow and strand lines.

LOOSE CURLS →
With very wavy or loose curls, the curves almost have sharp angles as they bend into the curls.

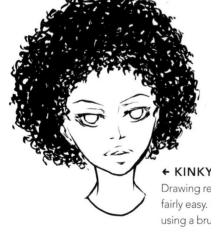

← KINKY CURLS
Drawing really kinky hair is fairly easy. It's just a matter of using a brushpen to make a lot of dense swirls.

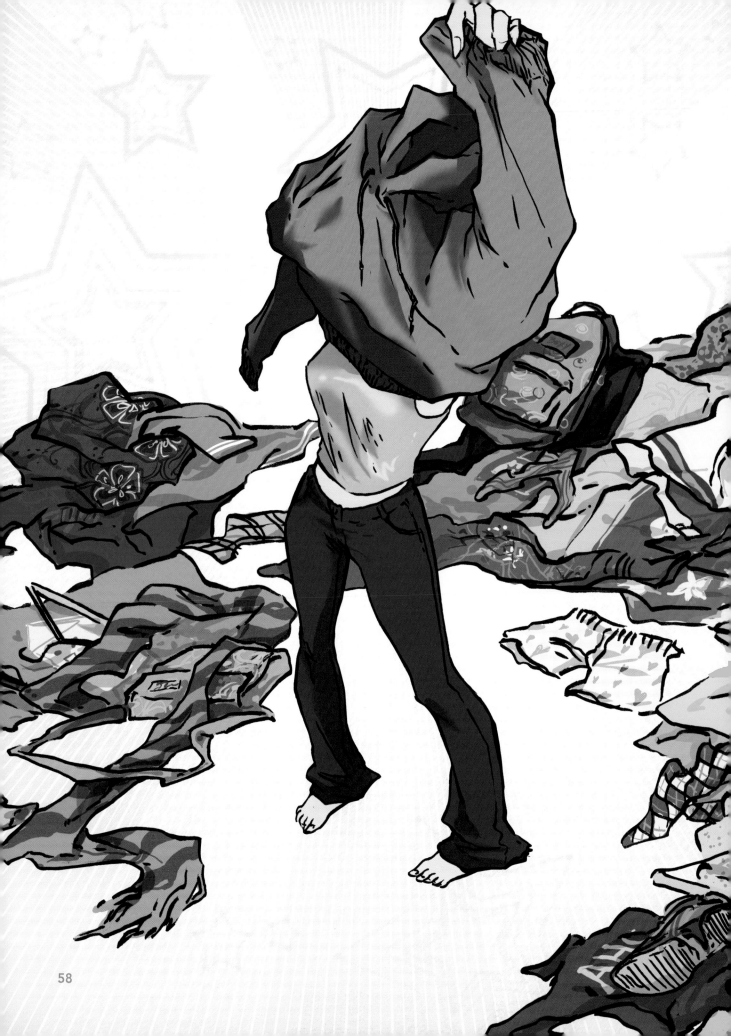

4 | Drawing Clothes

Whether characters have a full, colorful and fun wardrobe or wear the same thing day after day tends to depend on the preferences of the artist drawing them. But whether drawing the same three outfits over and over again, or coming up with something new every chapter, the more believable the clothing looks, the better the art is. Shirts which look like over-starched boxes aren't convincing or attractive; fabric follows the laws of gravity as much as anything else, and should stretch, wrinkle and flow according to how stiff it is and how your character moves.

This section offers short tutorials on how to draw different textures, as well as clothing references and ideas for filling out your own characters' wardrobes. While all the clothing shown is drawn on girls, the techniques and style considerations cross genders and will apply to your guy characters as well. Just remember to always keep your characters in mind when designing their wardrobes. How you choose to dress them will accentuate their personalities.

Fabric 101

A comic medium isn't an excuse to have clothes with no texture. Even in more realistic art, drawing fabric is simply a matter of showing the way it drapes or adheres to the figure it is on, as well as the way the light hits the surface.

HOW TO PORTRAY TEXTURED FABRIC

You don't have to color something in to show texture. Simple pencil strokes or inked line weight can effectively express texture.

STIFF FABRIC →
Starched, stiffer fabric can hold its own shape. The collar can be turned up, and the shirt doesn't drape like lighter fabrics.

← FABRIC THAT DRAPES
Lightweight fabric drapes on the body if it can't hold its own shape. Since the style of this shirt is loose and meant to drape, there are a lot of lines to show all the folds and creases in the fabric.

MOVEMENT OF FABRIC →
Consider how movement and weather affect clothes. The type of fabric is also a factor. A loose, pleated cotton skirt tends to flutter in a strong breeze as opposed to a tailored, more fitting skirt made of a heavier suede.

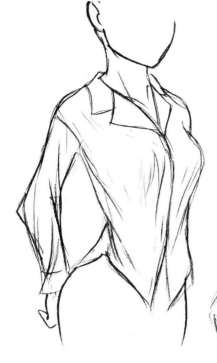

SILKS

Fabric like silk drapes easily and follows the curves of the body. It's light, so it doesn't hold its own shape, save for the creases.

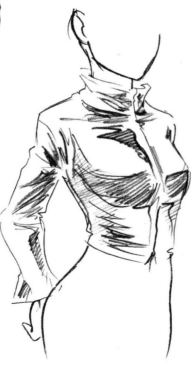

SHORT FUR

Using very short strokes for the jacket collar makes it look like fur. For the bottom portion of the jacket, give the short strokes more of a curve to make it look like wool.

LONG FUR

Use long, smooth strokes for longer fur. Draw small groups of lines to create clusters of fur.

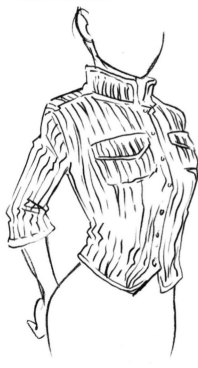

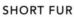

CORDUROY ↑

Fabrics like corduroy and denim are stiff enough to hold their own shape, as shown by the stand-up collar. Corduroy has a distinct texture, and you can show that by drawing lines to represent the tufted cords.

← LEATHER, VINYL AND RUBBER

Leather has a shiny quality to it. Vinyl and rubber do, as well. You can show this quality by creating a very stark contrast between the shadowed creases and the lit areas of the textile.

Shirts

There are lots of clothes to wear out there, and tops come in every shape, size and color. A good mixture of reference and make-believe can keep your characters each dressed in their own particular style.

**BABY DOLL SHIRT **
The collars vary from very close to the neck to an almost shoulder-width V-neck collar. These shirts are fitted and tend to stretch across the chest. Mind the location of the shirt seams.

T-SHIRT
A loose shirt like this drapes a lot more and the seams are more noticeable on the shirt sleeve. Adding details like seams make clothes look more finished.

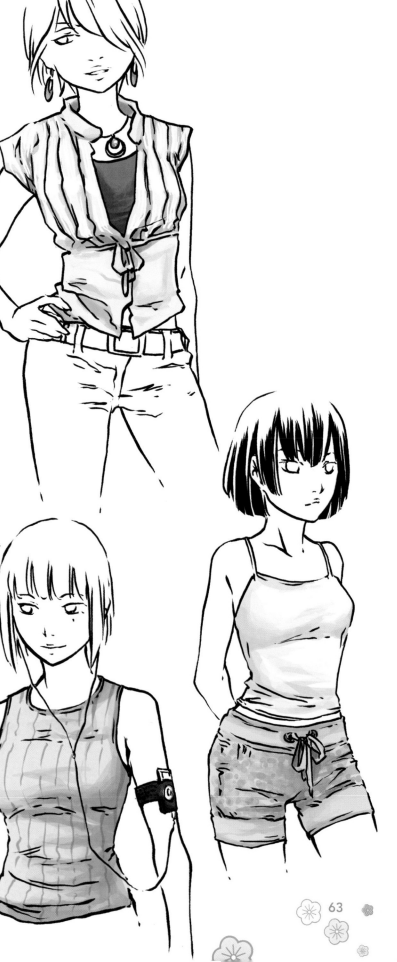

PARTIALLY-FITTED SHIRT ↑

The button-up and tie shirts shown here have areas of rumpled and stiff fabric. The collars are turned up and there are seams right under the chest, so the fabric on the upper portion of the shirts bunches up at that seam.

The fabric below the buttoned area on the shirt above flares out and creases radiate from that seam. The fabric below the tie on the shirt at right is smooth and tighter across the body so there won't be creases except where the body scrunches the fabric.

TANK TOP →

The fabric covering the torso is basically drawn like a fitted baby doll T-shirt. The lack of sleeves and varying necklines are generally the main differences.

Shirts With Collars

Collars might seem hard to draw, but just pay attention to the basic shape and you can add a collar to your shirt with ease!

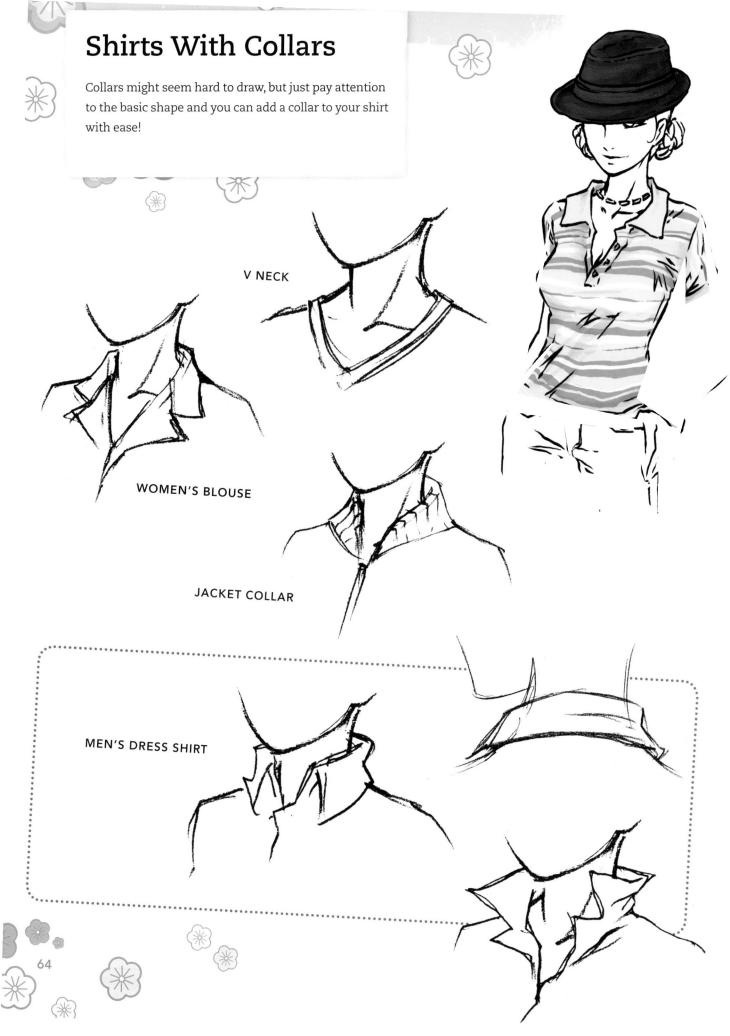

V NECK

WOMEN'S BLOUSE

JACKET COLLAR

MEN'S DRESS SHIRT

Choose the Best Style for Your Character

No matter which style shirt you choose, keep it in line with the personality of your character. Is she easy-going, fancy or frilly?

Sweaters

The seams at the shoulders are similar to those of a T-shirt, and you can make the fabric look thicker by drawing it farther away from the body.

DRESS FOR THE SEASONS

Soft, long and comfortable. Making sure your characters are dressed for the seasons can make all the difference between a black-and-white sunny summer day, and a clear chill winter morning.

Sweatshirts

The basic structure of a hoodie or sweatshirt is a T-shirt or tank with longer sleeves.

← BAGGY SWEATSHIRT
Here's a baggy hooded sweatshirt with the pocket in front.

PRACTICAL →
Some sweatshirts are practical, like this zip-up style used to keep a body warm when running outdoors in cool weather.

HOODED SHIRT →
The fabric in this style is thin and fit. Hood size and thickness can vary, but they basically all hang the same way.

STRICTLY FASHIONABLE
This type of hoodie is worn more for fashion than warmth.

Blazers and Long Coats

Blazers and dress jackets are well tailored. The initial focus is the shape. The seam is at the widest part of the shoulder. There is also the seam that goes from under the armpit to the bottom hem of the jacket. These coats are as much about style as keeping warm. Don't forget to take your character's budget into consideration!

SUIT JACKETS

Women's jackets have seaming that allows more room at the chest and is brought in more at the waist. Jacket lengths vary from beneath the waistline to low on the hips. Sleeve lengths also vary.

TRENCH COAT

1 CREATE THE BASIC SHAPE
The fabric of a long coat hangs straight down. It creases as the body moves.

2 FILL IN AND REFINE
Add buttons, sleeve tabs or pockets to suit your character's style.

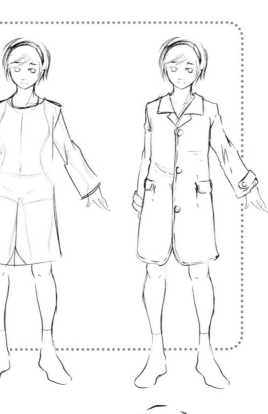

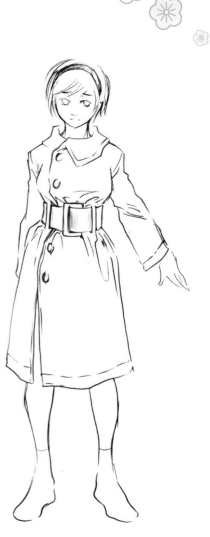

EXPERIMENT WITH THE DETAILS
The addition of a belt gives more shape to the body. The fabric bunches up where the belt cinches in at the waist.

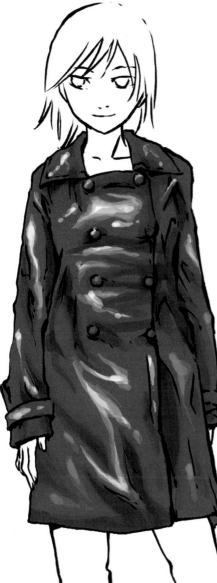

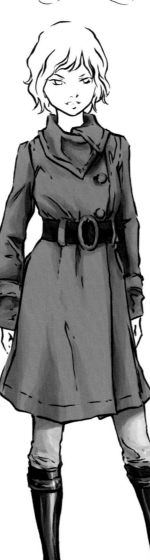

Warm Coats

To make your characters' wardrobes a little more interesting, not to mention less chilly, give them warm coats. Coats differ from each other in the nuances—from the line at the waist to the number of buttons or fabric choice. Not that there's any reason you can't spice things up with a neon green jacket, of course.

DRAW QUILTED FABRIC

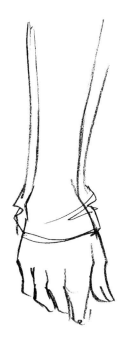 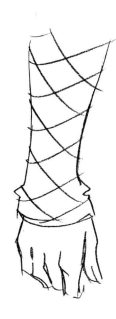 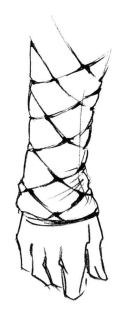 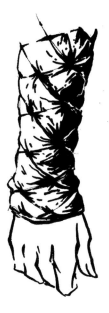

1 **CREATE THE BASIC SHAPE**
The sleeve is slightly fitted but far enough from the body to leave space for padding.

2 **DEVELOP THE SHAPE**
Draw a crisscross pattern of diamonds. The lines curve slightly at the edges to make it look three-dimensional.

3 **REFINE THE SHAPE**
As the seam lines intersect, the fabric's shadow makes it darker. The separate diamonds puff out, but are pulled in at the seams.

4 **ADD DETAILS**
Determine a light source. Shadow the crinkled fabric that goes into seams.

DRAW PUFFY FABRIC

1 **CREATE THE BASIC SHAPE**
The sleeve is looser and farther away from the body.

2 **DEVELOP THE SHAPE**
Draw the seam lines.

3 **REFINE THE SHAPE**
The fabric bunches up at the seams. Draw in the wrinkles.

4 **ADD DETAILS**
Add shadows and finish with inks.

Pants

Most people have a preferred style of pants, maybe liking them tight in the hips or loose in the legs. Some just never want to wear denim—others don't own anything but jeans. Keep your characters in mind while you design their wardrobes.

WAISTLINES
Let your character's personality decide which style to draw.

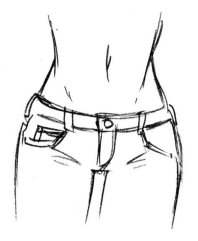

LOW-RISE

MID-RISE (AT THE NAVEL)

HIGH WAISTLINE

DRAW JEANS

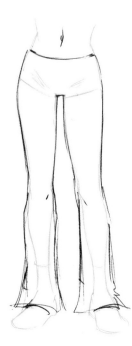
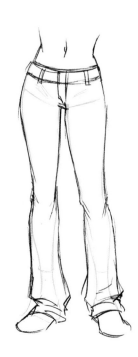
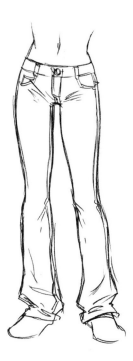

1 CREATE THE BASIC SHAPE

Boot-cut jeans are fitted from the waist to the knee. From there, the fabric flares out slightly and goes straight down.

2 DEVELOP THE SHAPE

Draw the belt line and the zipper flap. The length is a bit long, so the denim bunches up at the ankles.

3 REFINE AND ADD DETAILS

Add creases to the fabric and details like buttons, pockets and seams. If it is a fitted jean, the fabric stays fitted to the ankle. For a flare jean, the fabric moves away from the ankles, and won't bunch up as much.

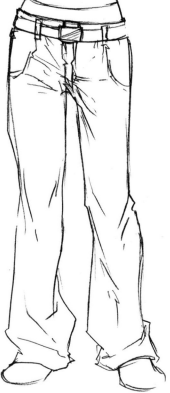

BAGGY JEANS

With baggy jeans, the crotch of the pants is lower and there are noticeably more creases in the fabric since it doesn't cling very closely to the body.

THIN DENIM

Some pants have the denim look of jeans, but are a thinner material, allowing for more movement of the material around the body.

Shorts

Shorts are drawn like long pants, just at shorter lengths. Be it capri, cargo, boxer-style or cutoffs, make sure the shorts you put on your characters match their personalities.

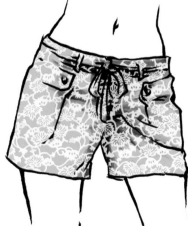

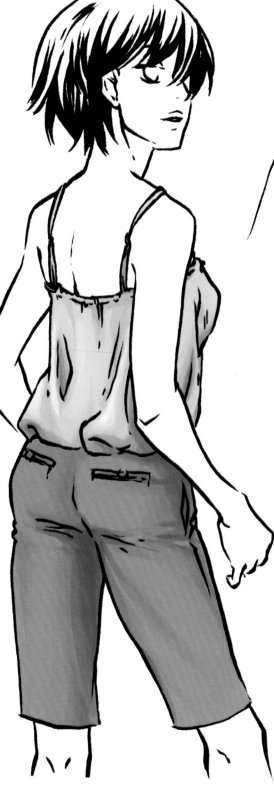

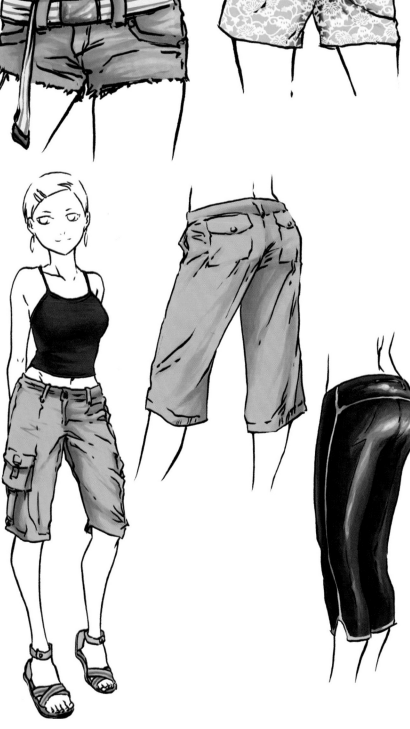

Swimwear

The construction of swimsuits is pretty simple. For the most part, the fabric follows the contours of the body. Certain suits have a little more detail for the sake of fashion.

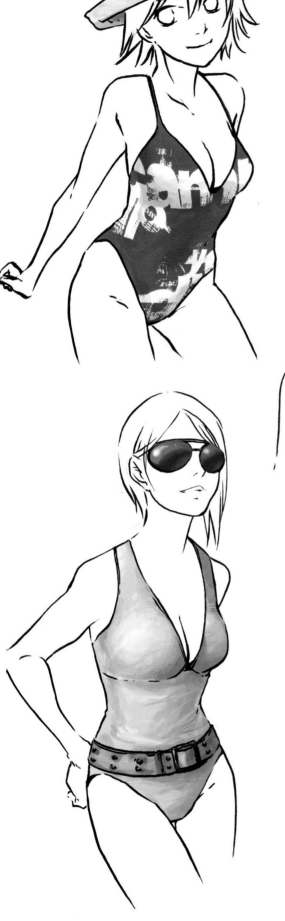

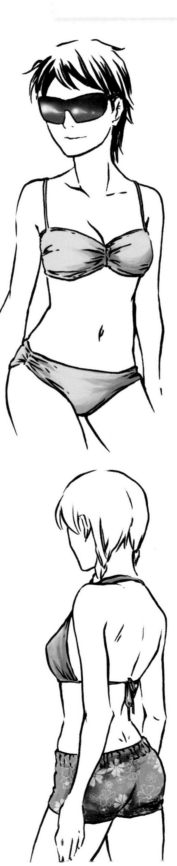

Skirts

Skirts range from fit and tailored to loose and flowing. The types of waistlines are similar to pants, from low- to high-rise, although the terms might be different.

PENCIL SKIRTS
These types of skirts are very tailored and will follow the form of the body.

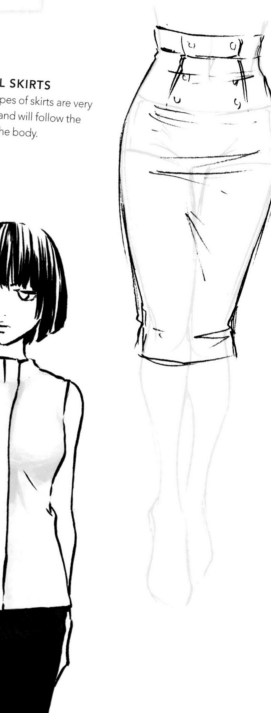

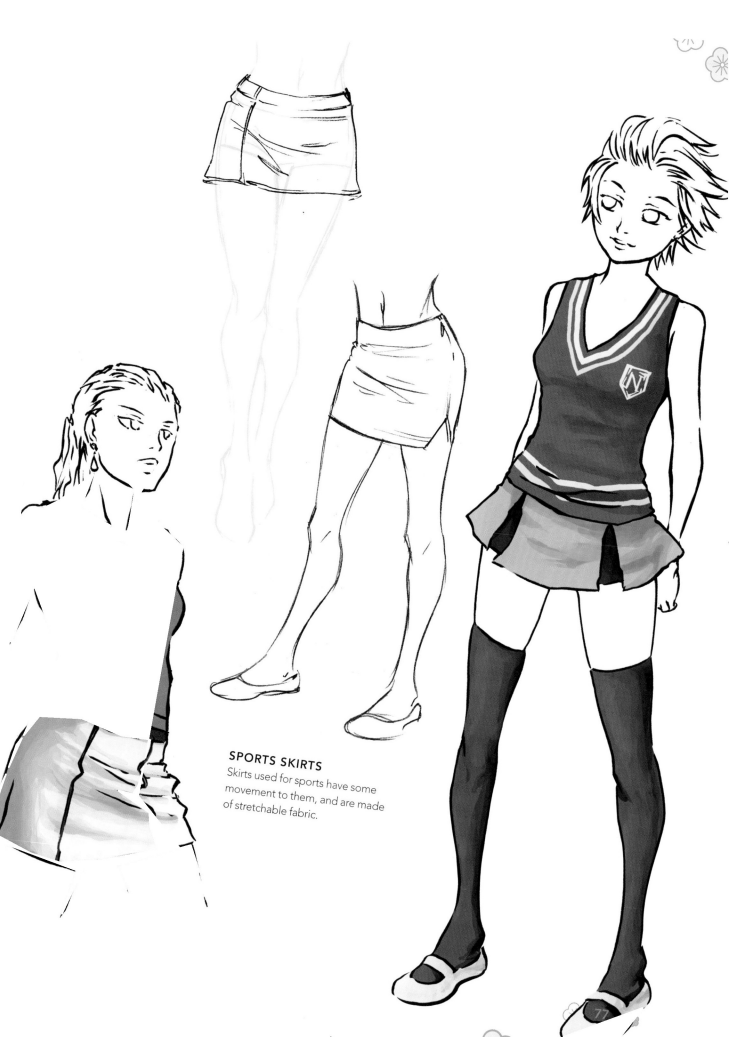

SPORTS SKIRTS

Skirts used for sports have some movement to them, and are made of stretchable fabric.

More Skirts

LOOSE SKIRTS

Loose skirts have a lot of movement—they move with the body and can be disturbed by wind.

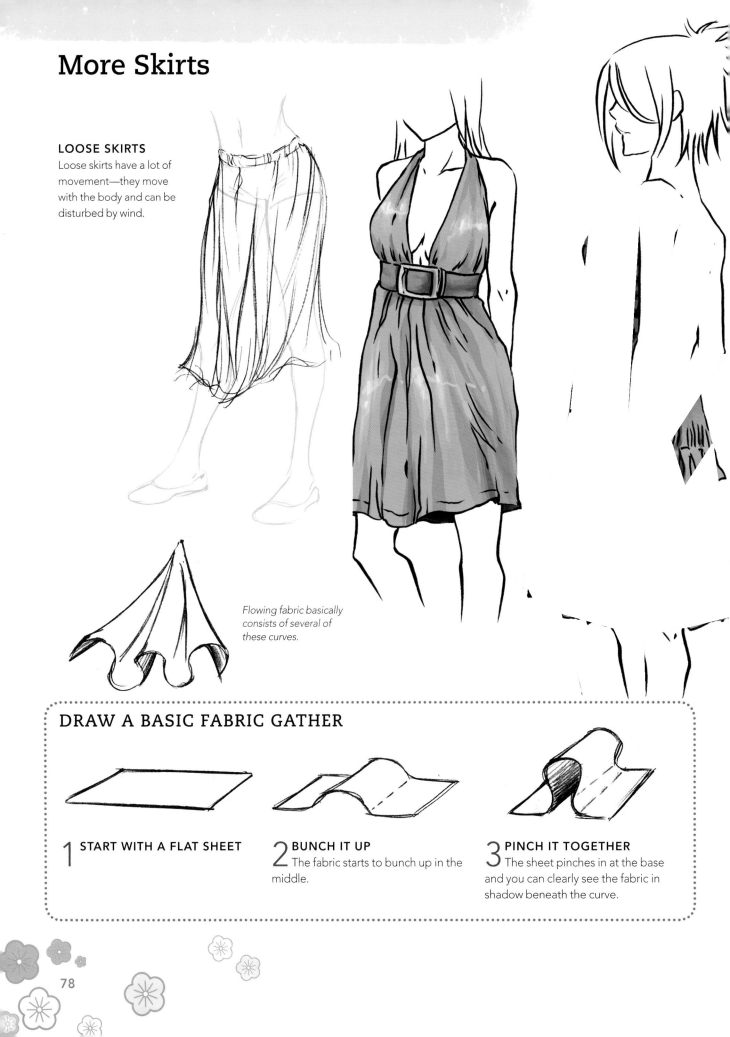

Flowing fabric basically consists of several of these curves.

DRAW A BASIC FABRIC GATHER

1 START WITH A FLAT SHEET

2 BUNCH IT UP
The fabric starts to bunch up in the middle.

3 PINCH IT TOGETHER
The sheet pinches in at the base and you can clearly see the fabric in shadow beneath the curve.

DRAW A RUFFLED SKIRT

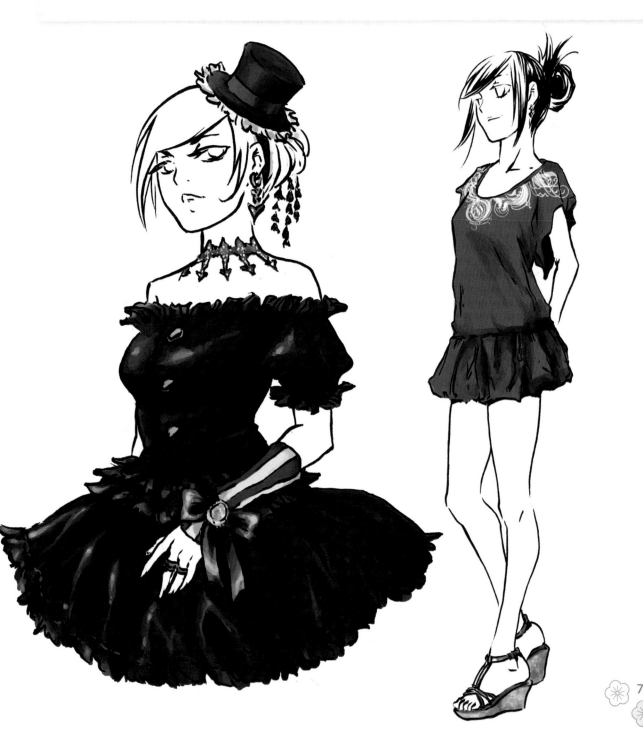

1 CREATE THE BASIC SHAPE
The ruffles don't have to be very planned out. Sketch a skirt hem with random curves.

2 DEVELOP THE SHAPE
Follow the curves and add more definition to the fabric.

3 REFINE AND ADD DETAILS
Clean up the pencils. Define the shadowed areas of the skirt by filling them in with a darker tone.

Frilly and Formal Dresses

The bodice of a dress is similar in structure to a shirt, and the lower portion is simply a skirt.

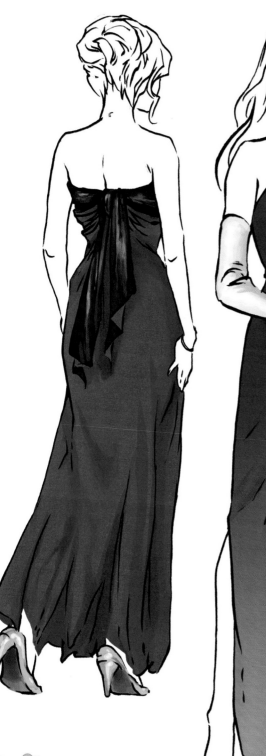

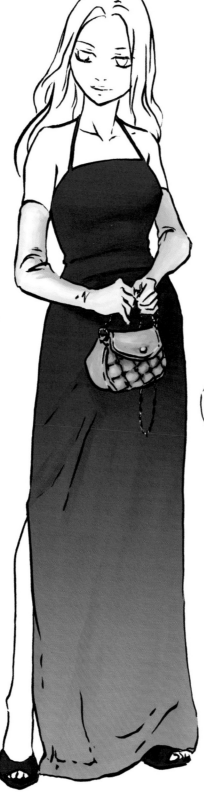

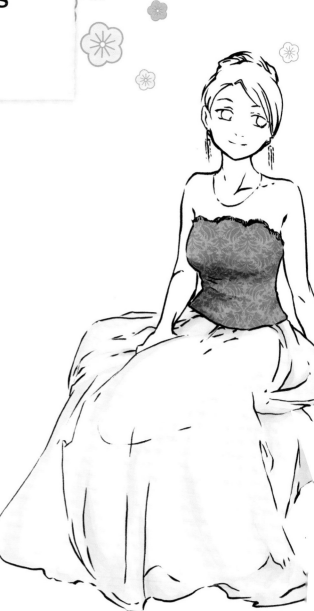

FITTED/LOOSE COMBO

Many formals are a combination of a structured top and a very flowy fabric for the skirt. In the example above, the skirt fabric is very light, and the construction involves several layers that make it puff out.

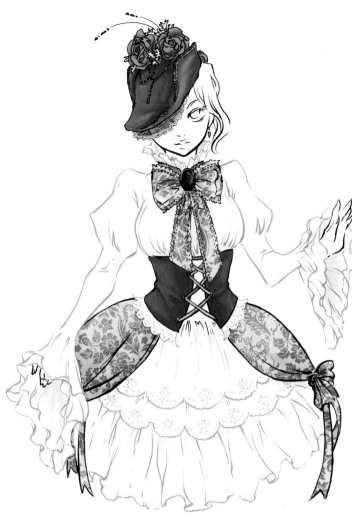

DRAW LACE

1 CREATE THE BASIC SHAPE
Rough in the general pattern of the lace.

2 DEVELOP THE SHAPE
The top layer of lace has a scalloped edge, while the two bottom layers consist of fabric pulled tightly into a seam. Use the same steps for these two bottom layers as you would when drawing flowing fabric.

3 REFINE THE SHAPE
Add a set pattern of dots to give the effect of lace. Unless you really need to show some detail up close, that's all you'll need to draw. To finish it off, a piece of ribbon with scalloped edges covers the seam that joins the skirt to the lace.

4 FINISH IT WITH SOME INK
Add a shadow beneath each layer of lace to show the gap between the fabric layers and add shadow between the lace and fabric folds.

Hats

Not everyone is a hat person, but there is a hat for every type of person. Whether sporty, fashionable or professional, a hat can top off an outfit and tell us what sort of day your character is planning.

BASIC HAT STRUCTURE

The part of a hat that covers the head will generally need to be fitted on the head tight enough to stay put. Designs and colors change it up. The hats above all have brims, and all the brims are floppy, while the part covering the head changes from close fitting to more structured.

← TOP HATS
Play with the brim and the top to create hats with stiff structure, like top hats and Stetsons.

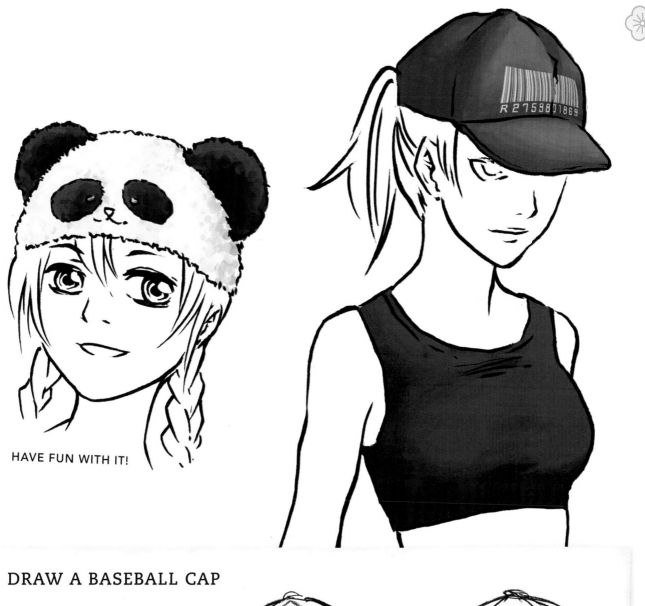

HAVE FUN WITH IT!

DRAW A BASEBALL CAP

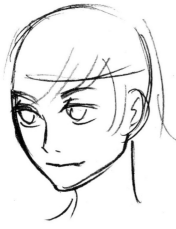

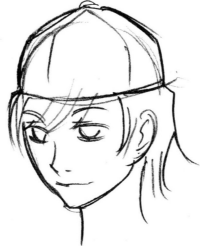

1 ESTABLISH THE PLACEMENT
Draw the line for the bottom of the cap, or a curved line across the forehead.

2 CREATE THE BASIC SHAPE
Sketch the outline of the cap. A comfortable fit is often tight enough that the hair bunches out from where the hat ends.

3 REFINE THE SHAPE
The bill of a cap has a slight curve to it. It goes up in the middle and the sides come down.

Gloves and Mittens

Depending on the type of glove or mitten, creating it is a matter of drawing over the lines of the fingers and adding visible seams.

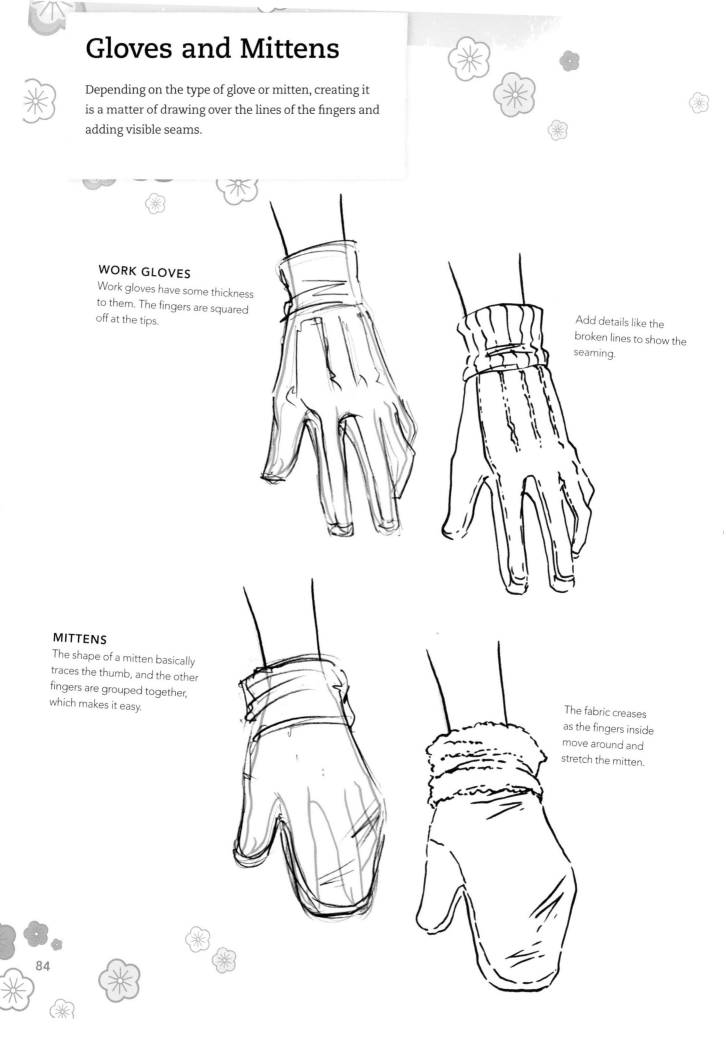

WORK GLOVES
Work gloves have some thickness to them. The fingers are squared off at the tips.

Add details like the broken lines to show the seaming.

MITTENS
The shape of a mitten basically traces the thumb, and the other fingers are grouped together, which makes it easy.

The fabric creases as the fingers inside move around and stretch the mitten.

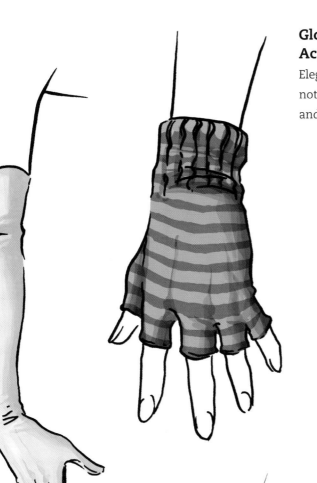

Gloves Are a Fun Way to Accessorize Your Characters

Elegant, fashionable or practical, gloves and mittens not only help show the season, they can set the mood and show the personality of your character.

This type of glove is made from soft, fluffy fabric, so it is thicker and the lines are broken up to show the fuzzy texture.

Leather gloves are tight, so there isn't much extra thickness around the hand and fingers.

Scarves

Accessories, or lack of them, are an easy way to add some personality to your character. Scarves have the double effect of conveying chilly weather.

DRAW A SCARF

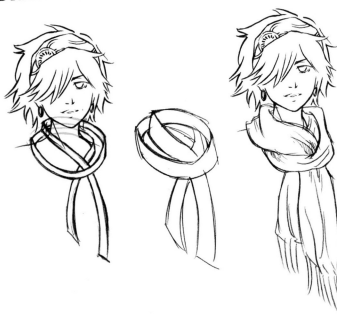

1 CREATE THE BASIC SHAPE
Determine the path of the scarf. Use a simple ribbon as a guide.

2 DEVELOP THE SHAPE
Make the band wider.

3 REFINE AND ADD DETAIL
Draw the fabric, using the band as a guide, and drape the fabric as it wraps around itself. Add darker areas to indicate folds and overlaps in the scarf.

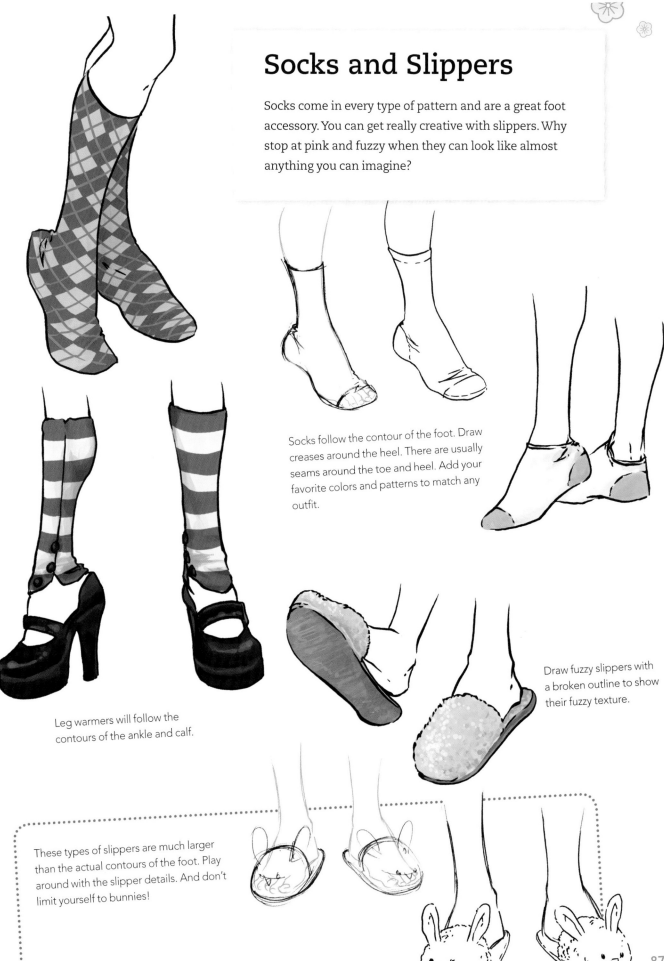

Socks and Slippers

Socks come in every type of pattern and are a great foot accessory. You can get really creative with slippers. Why stop at pink and fuzzy when they can look like almost anything you can imagine?

Socks follow the contour of the foot. Draw creases around the heel. There are usually seams around the toe and heel. Add your favorite colors and patterns to match any outfit.

Draw fuzzy slippers with a broken outline to show their fuzzy texture.

Leg warmers will follow the contours of the ankle and calf.

These types of slippers are much larger than the actual contours of the foot. Play around with the slipper details. And don't limit yourself to bunnies!

Sandals, Sneakers and Sensible Shoes

Make sure your characters have a few pairs of everyday footwear in their wardrobes, unless you have a good reason he never puts on anything but socks, or she always wears high heels.

FLIP-FLOPS AND SANDALS

The general shape of flip-flops or sandals is smaller at the heel and gets wider to make room for the toes. The most visible difference between the right and left foot is the placement of the straps and where they attach to the base.

PRACTICAL, WALK ABOUT TOWN SHOES

While not necessarily the style that stands out in a crowd, a practical shoe may be the shoe of choice for your character.

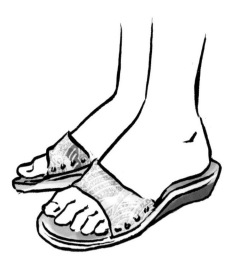

DRAW LACED-UP SHOES

1 **ESTABLISH PLACEMENT**

Sketch the tongue of the shoe and rough in the lines of the laces.

2 **CREATE THE BASIC SHAPE**

Draw the shoe around the foot.

3 **DEVELOP THE SHAPE**

Start to define the parts of the shoe.

4 **REFINE AND ADD DETAILS**

Clean up the pencils and add the laces and other final touches, like visible stitching.

Heels

Definitely not for everyone, heels still lend a certain amount of sex appeal, and come in thousands of different styles. From business casual to strappy stilettos, what sort of heels they are wearing can say a lot about a girl...or guy.

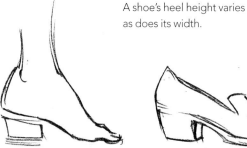

A shoe's heel height varies as does its width.

With high heels the foot has a very high arch, almost tiptoe.

DRAW HEELS AT AN ANGLE

1 CREATE THE BASIC SHAPE
Start by drawing the foot with a basic slip-on shape. You could add just a bit more detail if you were drawing someone with slip-on shoes.

2 DEVELOP THE SHAPE
Make the toe of the shoe pointed or squarish, depending on the style of shoe you're going for. Because of the angle, the heel of the shoe looks shorter than it actually is.

3 REFINE THE SHAPE
If you want, you can add more details to the shoe.

If the Shoe Fits...

Once you get the basic idea, play with the style. Be it fancy, fun or funky, each character will have her own favorite look.

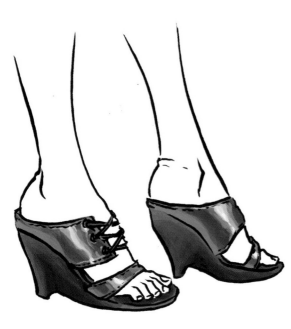

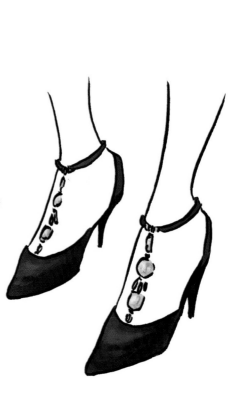

Boots

There's no reason galoshes can't be fashionable! Toss out that old yellow style and make them whatever color you want. Boots can range from trendy to necessary, depending on your character's line of work.

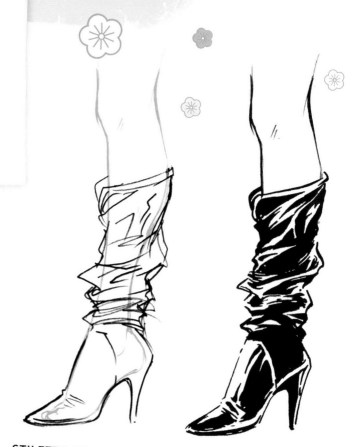

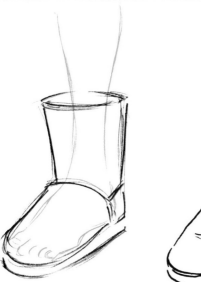

WARM BOOT

This type of boot is lined with wool, so it should be drawn loosely around the foot, leaving adequate room for the padding inside. The outer material is suede and is flexible, so creases will appear when the ankle flexes and moves the boot.

STILETTO SCRUNCH BOOT

This boot is constructed like a heeled shoe, with the ruching starting above the ankle—imagine that you pushed down on the very top of the boot and all the fabric got scrunched up.

RAINBOOTS AND GALOSHES

These types of boots can actually be pretty stylish. The tops can be fur-lined, scalloped or belted, and the boots themselves can be any pattern you choose.

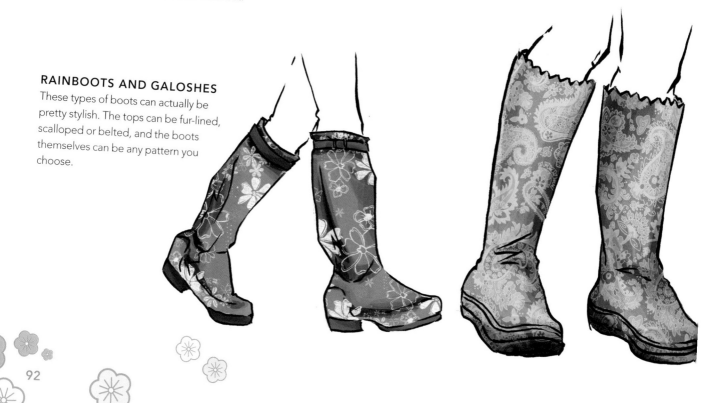

DRAW LACED-UP BOOTS

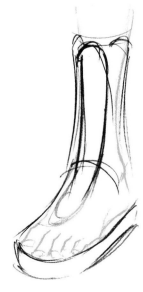 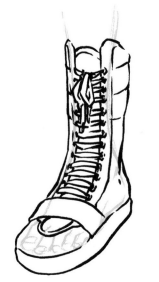 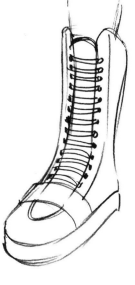 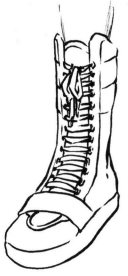

1 ESTABLISH PLACEMENT
The basic outline is like drawing a regular sneaker, but the shoe's tongue and top are higher on the leg.

2 DEVELOP THE SHAPE
Place the laces, keeping them evenly spaced. Draw additional design elements.

3 ADD DETAILS
Add the finishing detail and the laces tied at the top.

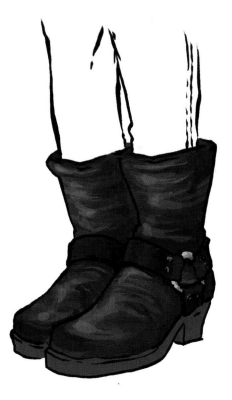

CLASSIC COMBAT BOOT

HARNESS BOOT

Purses and Bags

A girl may have one purse she uses every day, be it a handbag or colorful tote, or a purse to match every outfit! Either way, whether stashing wallets, glasses, mp3 players or very small animals, you should never want for the right kind of bag if you just use a little imagination.

PURSE STRAPS

When it comes to bags with body straps, mind the direction the strap faces and pay attention to the way it twists.

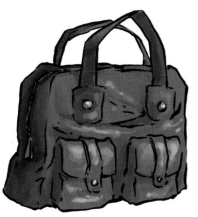

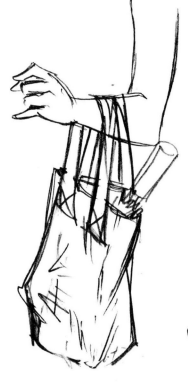

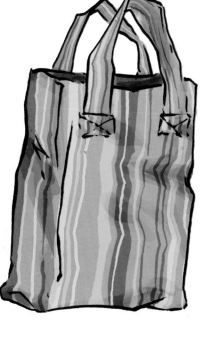

FLOPPY BAGS

Some bags take the shape of whatever's inside.

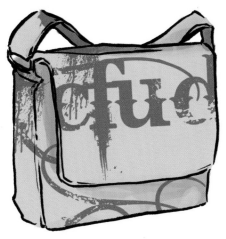

STRUCTURED BAGS

Certain purses have a very structured construction, and the shape isn't affected at all by the contents.

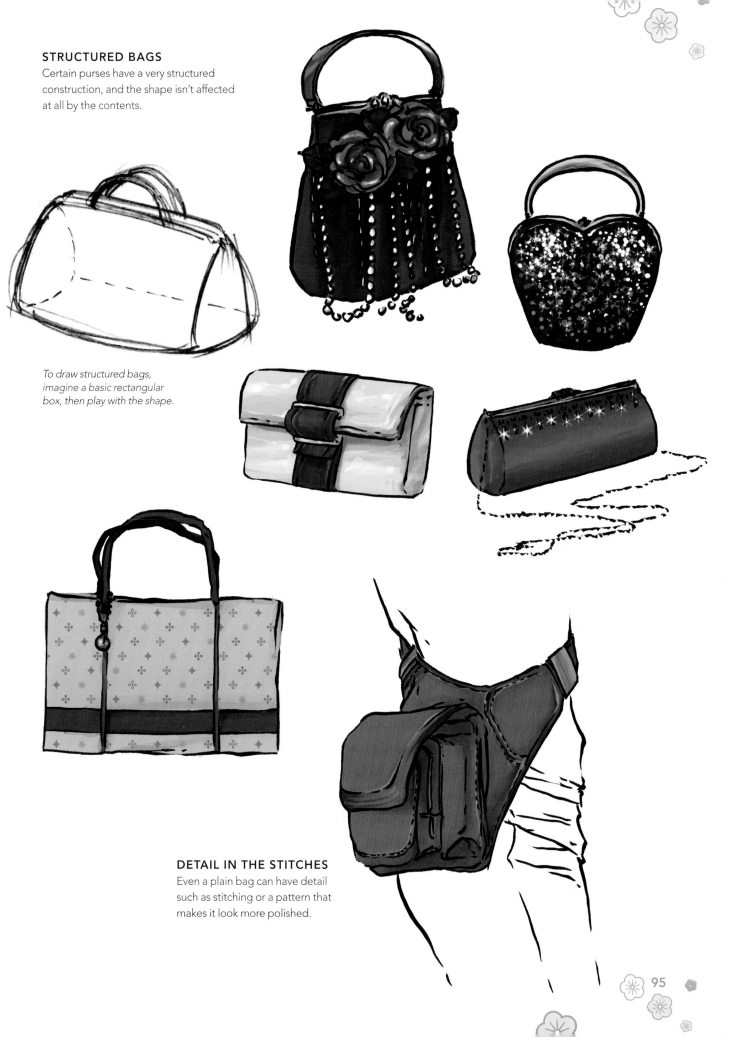

To draw structured bags, imagine a basic rectangular box, then play with the shape.

DETAIL IN THE STITCHES

Even a plain bag can have detail such as stitching or a pattern that makes it look more polished.

Other Fun Accessories

Items like jewelry, glasses and other accessories are props that give clues to a character's personality.

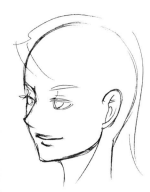
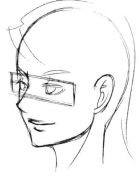
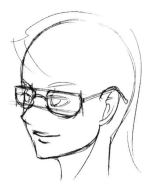
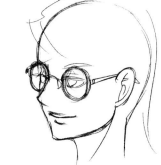

EARRINGS AND NECKLACES

Earrings, necklaces and other types of jewelry can draw from an endless variety of lengths, materials and construction. They can be simple and small, or over the top and chunky.

DRAW GLASSES

1 CREATE THE BASIC SHAPE

Drawing glasses of any kind starts the same way. Use a rectangular shape in front of the eyes to act as a guide to line up the lenses. It's especially useful with the face at a two-thirds angle.

2 ADD THE DETAILS AND REFINE

Then just draw the shape of the lenses and the curved piece that goes over the bridge of the nose. The hinges are on the upper portion of the lenses. Finish it off with the earpiece.

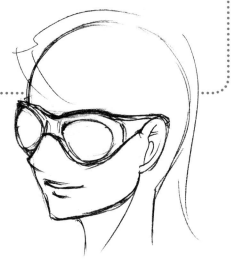

Once you have the basic idea, play with shape and details to create the perfect glasses for your character.

DRAW AN UMBRELLA

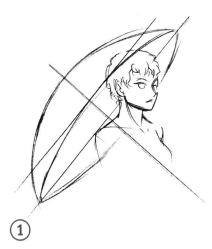

①

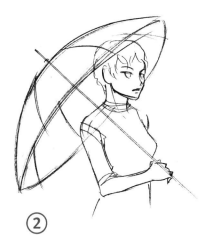

②

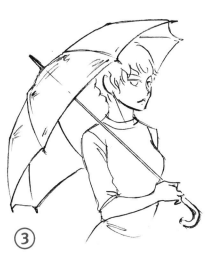

③

1 **CREATE THE BASIC SHAPE**
Draw a cross with ninety-degree angles. Draw a cup shape.

2 **ADD SPOKES**
Let the spokes radiate from the center of the umbrella.

3 **PLACE THE DETAILS**
The material is stretched between the spokes, so draw a few stress lines.

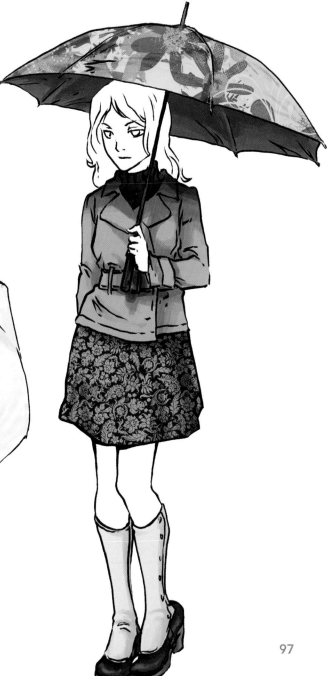

5 | Cool Looks, Step by Step

There is really no way to tell you how to go about creating characters. Do you design them first and then write a story to fit what you have drawn? Or do you come up with a history and create a picture to fit it? Maybe they just start as a random, passing idea, and before you know it, you're figuring out love interests and favorite colors. Whatever works for you, this section is about fleshing out an idea and an image, by representing stereotypical archetypes that may or may not actually fit said stereotype. Keep in mind that creating a unique character doesn't have to be about pulling the wildest possibilities into one place; developing a believable character that your audience can sympathize with and care about centers around giving them someone they can learn to understand. This depth is what separates a beloved mousy bookworm from a forgotten one.

The next challenge is to convey all of that with your art. People talk, gesture, stand, dress and make different expressions depending on the things they have experienced and the life they have lived. Whether it is a socially awkward boy who never dresses well and always holds himself stiffly, or a confident and cheerful young girl who seems determined to bounce through life, this section will show you how to put that personality into your character design.

QUEEN of DRAMA

A few lucky stars are just born to drama, exuding it not only on the stage, but in every other aspect of their lives. Susan Rachel Hartfield loves the spotlight, and happens to be pretty good at getting into it, whether it takes hard work, long crying bouts or just accepting the lead female role. Pretty, and definitely a bit petty, Susan doesn't quite understand why her peers don't enjoy her company as much as she does. But while her attention to self may not have made her popular, it has found her a solid place on the stage. So there's no doubt that one day soon she'll be successful enough that even her busy family and friends will find the time to come watch a show.

PERFECTLY POISED SUSAN

Study	**
Sport	*
Social	**
Recreation	***
Family	*
Dramatics	*****

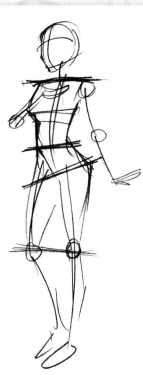

1 STRIKE A POSE
Susan is always poised—or should I say posed? She always stands and sits up straight, holds her head up and gives off haughty vibes. The stiff angles of her arms and legs are unnatural here, giving away her insincerity.

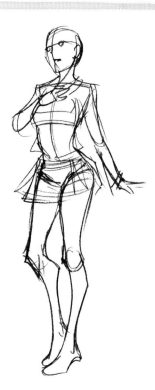

2 FILL IT IN
Place the facial features and draw the body structure. She's very statu-esque and doesn't make unnecessary movements, so her clothes are fairly still. Susan is rather dramatic, and hand movements often accompany her words.

3 ROUGH IN THE DETAILS
Rough in the hair and add detail to the facial features and expression. Her face is expressive, but subdued. Mostly, she gives her mood away with her eyes, eyebrows and the set of her mouth.

Other Looks for Susan

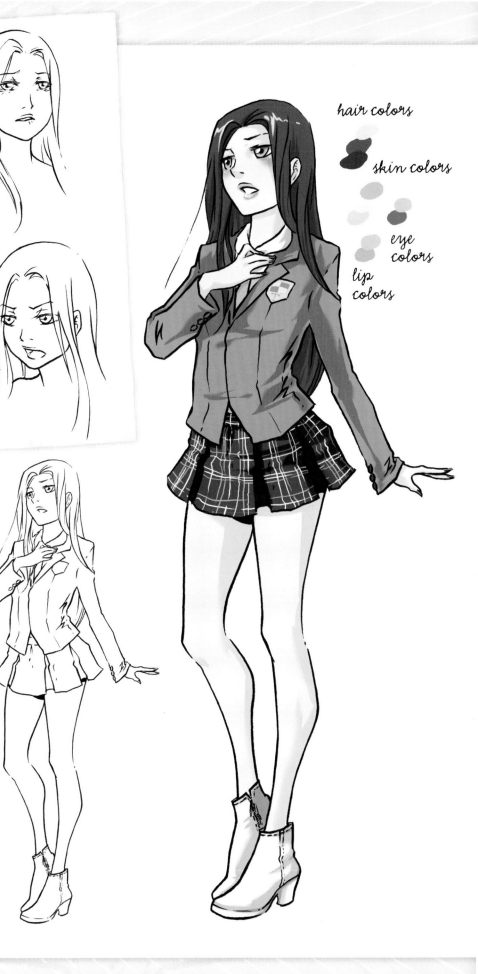

hair colors

skin colors

eye colors

lip colors

4 **CLEAN-UP AND INKS**
Keep the ink lines clean and smooth, especially since Susan's clothes are perfectly pressed. Aside from the slight wrinkles in the fabric due to movement, there are few crinkled lines.

5 **COLOR**
Susan always wears colors that complement her complexion and hair.

The SPORTSWOMAN

Making a good case for nature over nurture, Ruth Maroi shuns her well-to-do parents' desire for a pretty little princess in favor of any athletic sport she can get her legs into. Baseball? Soccer? Even football if she can find someone willing to take her on. Which doesn't happen often, as Ruth has a bit of a reputation for backing up her words with her fists when necessary, regardless of whether it's standing up for herself or someone else. Thanks to Ruth's preoccupation with sports demanding her time and energy, she sometimes has trouble making room for a social life. But with her all-star abilities and relaxed personality, her peers often find themselves gravitating toward her, often without her notice.

RELAXED RUTH

Study	***
Sport	*****
Social	**
Recreation	****
Family	*
Straightforward	*****

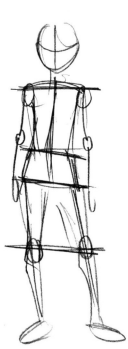

1 STRIKE A POSE
Ruth has a very relaxed stance. Her shoulders slump and she's almost slouching. You can set up this careless pose by making sure the lines of her shoulders, hips and knees are all going down in the same direction.

2 FILL IT IN
Fill in the body structure. Ruth is an athlete so she's got a bit more muscle on her than most females. Her frame is still pretty small, but strong.

3 ROUGH IN THE DETAILS
Ruth's hair is short and slightly unkempt. It looks like she just runs her hand through it and doesn't fuss with it much. Ruth prefers loose, comfortable clothes, so the items she wears are usually baggy and slightly rumpled. Because of her small chest and narrow hips, you can't even see her figure here.

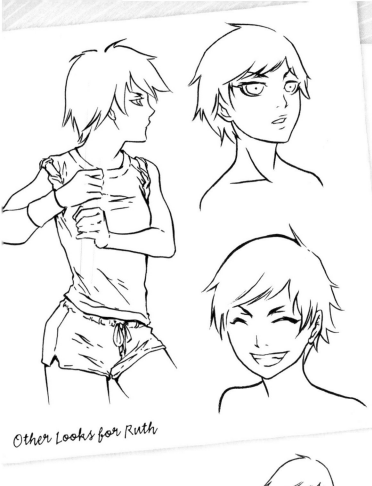

Other Looks for Ruth

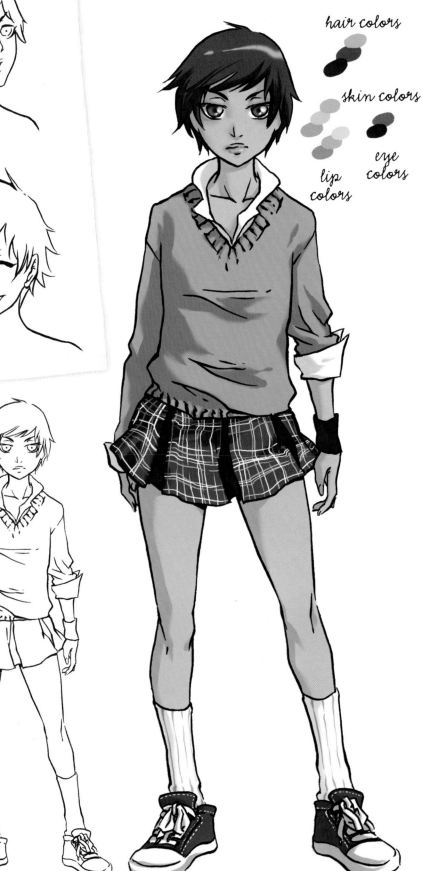

hair colors

skin colors

lip colors

eye colors

4 CLEAN-UP AND INKS
The sweater is baggy, so draw in folds where the fabric hangs and bunches up, but don't overdo it. The skirt is also wrinkled, so the ink lines are a bit squiggly.

5 COLOR
Dark colors. Not particularly blacks or browns, but deep tones. No pastels for this girl.

HAPPY-GO-LUCKY

Some people are never boring, or just never bored. Always able to find a way to entertain herself, Michelle Theodore Jeffers tends to enjoy life, the universe and everything—usually with a skip in her step and an annoying song stuck in her head. While she has few close friends, there's almost no one who doesn't enjoy her company, as she effortlessly manages a precarious balance between exuberant and annoying. So whether it's dragging her father on wild spelunking adventures or concocting devious plans to get her friends to hook up—no matter what's happening, Teddy can always be counted on to be having the most fun in any situation.

TRENDY TEDDY	
Study	*
Sport	***
Social	****
Recreation	*****
Family	*****
Hijinks	*****

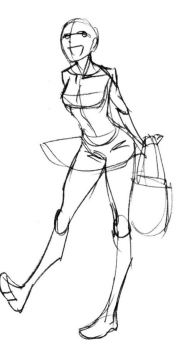

1 STRIKE A POSE
Teddy's a very lively person, so her stances are always exaggerated and full of movement. The waistline is a curved line rather than a straight line, since she is bending forward.

2 FILL IT IN
Draw the body and facial structure. Like her stance, her expressions are also exaggerated. Start roughing in clothing. The skirt flares out, showing that she's rocking back quickly on her left leg.

3 ROUGH IN THE DETAILS
Add detail to the facial features and expression, draw the hair and finish the clothes. Teddy moves around a lot, so her skirt is constantly in motion. There are a lot of creases near the waistband seam of the skirt, because the pleats are moving around a lot. The inside pleat of the skirt is more visible as the fabric swishes around.

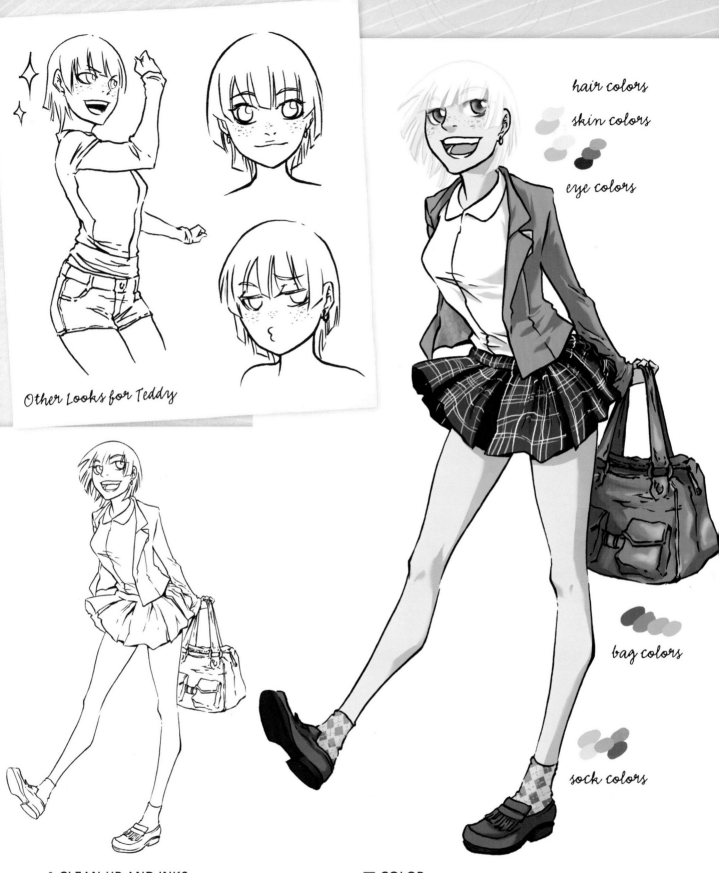

Other Looks for Teddy

hair colors

skin colors

eye colors

bag colors

sock colors

4 CLEAN-UP AND INKS

This is a chance to add in more subtle detail, like a slightly uneven line weight on the jacket and skirt to make them look a bit rumpled.

5 COLOR

There's a bit more personality coming from the colors of her socks and bag. It's always bright, vibrant colors for Teddy.

The **SOCIALITE**

Popularity can be effortless if you happen to look, smile and act like Odessa James. With her exotic appearance, excellent wardrobe and honest personality, Odessa turns the heads of men and women alike. And never one to be just a pretty face, Odessa has a complex understanding of people to back up all the time she spends with them, leaving her with friendships others might think unexpected, and a social circle that encompasses most of the map. Odessa is often on the social scene—usually by masterminding Collin's epic parties.

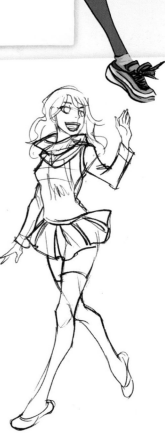

ODESSA IS ALWAYS SMILING	
Study	★★★★
Sport	★★★
Social	★★★★★
Recreation	★★★★★
Family	★★★
Perceptive	★★★★★

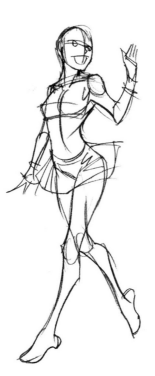

1 STRIKE A POSE
Odessa leads a busy life. She's almost always on the move and retains good posture.

2 FILL IT IN
Draw the body and facial structure. Odessa's very friendly and always smiling, and there is a lot of movement in her clothes; she always walks with purpose.

3 ROUGH IN THE DETAILS
Add detail to the facial features and expression, draw the hair and finish the clothes. Odessa's hair is styled, but casual enough that she can tie it up if she has to.

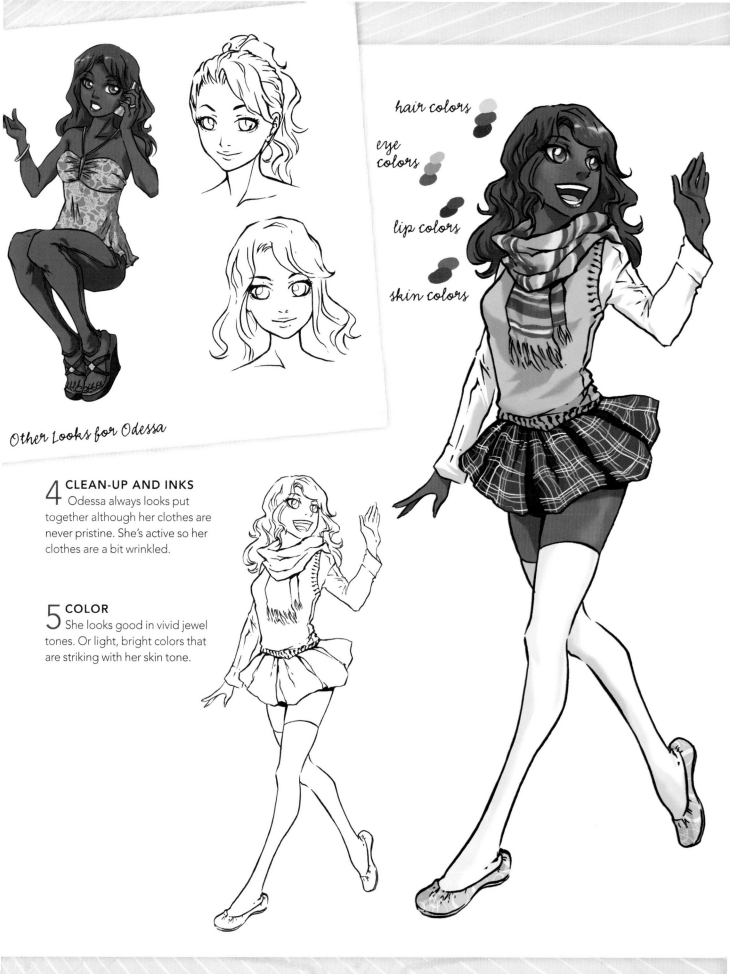

hair colors

eye colors

lip colors

skin colors

Other Looks for Odessa

4 **CLEAN-UP AND INKS**
Odessa always looks put together although her clothes are never pristine. She's active so her clothes are a bit wrinkled.

5 **COLOR**
She looks good in vivid jewel tones. Or light, bright colors that are striking with her skin tone.

GIRL NEXT DOOR

There's nothing wrong with being "the girl next door," or with having a resumé as long as your arm. A big believer in hard work and experiencing life just for the sake of it, Trey McKinney has taken every sort of seasonal position available—Christmas elf, renaissance festival performer, cashier on Black Friday, and even some volunteer work now and then. She doesn't need the money, but understands the benefits of doing things for herself. While her eternally positive attitude has left her social skills a little lacking, and she is often oblivious to people around her, whatever time Trey has left over from work is always available to be eaten by friends and potential significant others, even if she can't really tell the difference.

ETERNALLY POSITIVE TREY

Study	***
Sport	*
Social	***
Recreation	***
Family	**
Reliable	*****

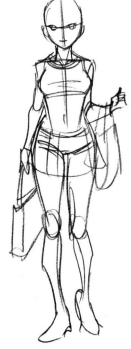

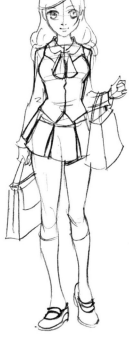

1 STRIKE A POSE
She's very calm, proper and lady-like. Trey doesn't move around too much, either.

2 FILL IT IN
Draw the body and facial structure. Trey has an average body type. The pose isn't anything remarkable, but her right hip juts out a bit since her weight is on that leg. To give the picture a little more interest, I bent an arm up and added a shopping bag.

3 ROUGH IN THE DETAILS
Add detail to the facial features. For the most part, Trey usually has a small smile on her face, and the set of her eyes is open and friendly. Her hair is always neat, and although it's wavy, the strands are always in place.

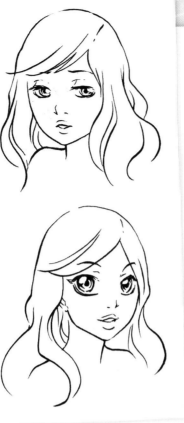

Other Looks for Trey

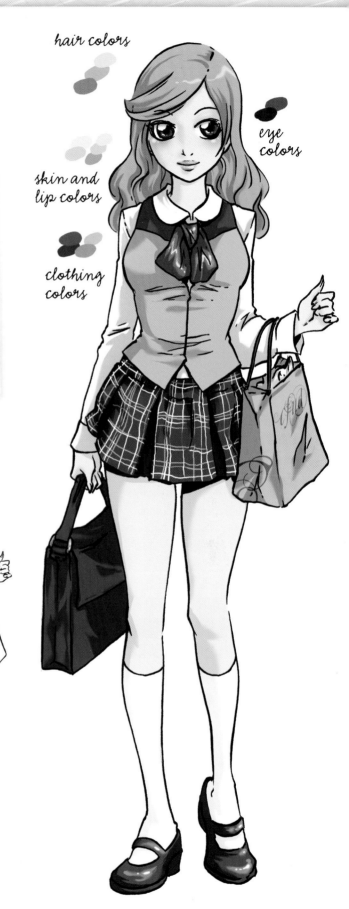

hair colors

eye colors

skin and lip colors

clothing colors

4 **CLEAN-UP AND INKS**
Keep the lines smooth and draw a minimum of fabric creases. Add just a few where her limbs bend, where the vest stretches at her waist and under the chest and the creases at the seam of the skirt.

5 **COLOR**
Trey wears a large array of colors from dark tones to pastels, but her outfits always match.

The INDEPENDENT

Being a starving artist is all about focus, dedication and a frugal wallet. When not working to make rent, Rebecca "Beck" Williams assembles her rebelliously stylized wardrobe by shredding her own jeans, sewing on patches and otherwise altering whatever looked like it had some potential at the local thrift store. Her other hobbies include practicing guitar and piano. Not nearly as scary as her punkish appearance and bored looks might lead people to believe, Beck is open-minded, calm and personable. With courtesy superior to most, she's one of the few people with the patience to make friends with almost any type, even a certain drama queen.

EFFORTLESSLY COOL BECK

Study	***
Sport	*
Social	**
Recreation	****
Family	*
Experimenting	*****

1 STRIKE A POSE
Beck is just effortlessly cool. Her posture is confident and relaxed, and she slouches a lot.

2 FILL IT IN
Draw the body and facial structure. Beck's eyes always have a half-lidded, somewhat bored look. Start adding the rough details of the clothes.

3 ROUGH IN THE DETAILS
Add detail to the facial features and expression, draw the hair and finish the clothes. Her shirts are wrinkled and untucked, as are her skirts. Beck also enjoys having a lot of mismatching accessories—rings, studded bracelets, ties, suspenders.

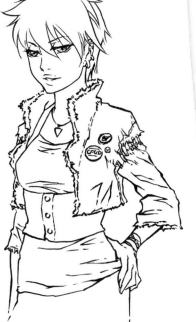

Other Looks for Beck

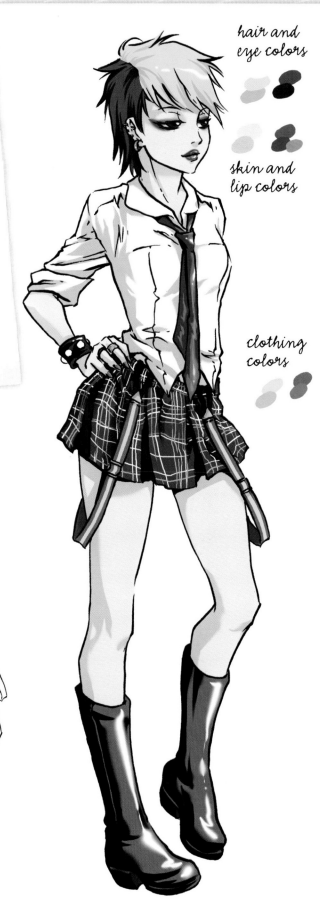

hair and eye colors

skin and lip colors

clothing colors

4 **CLEAN-UP AND INKS**
The lines for the shirt and the skirt are a bit shaky, to make the fabric appear wrinkled. There are a lot of creases in the fabric as well as some visible seams on the shirt. Her hair is styled messily, so a lot of the strands just go off in different directions.

5 **COLOR**
Anything and everything. The colors don't need to match; actually, Beck prefers it that way.

WELL-BALANCED

There are advantages to being the well-balanced sort. Philip Singh is the natural leader type, thanks to a mixture of dependability and seriousness, honesty and understanding. He doesn't push anyone too hard, not even himself, but has a good idea of what others are capable of, and how to bring it out of them. This ensures that almost all of his peers think well of him, even if very few are particularly close. Whether seeking out something to do on a Friday night or dedicating himself to getting ahead on his work, Philip almost always accomplishes what he sets out to do in the most effective way possible.

SERIOUS BUT SURPRISING PHILIP	
Study	****
Sport	**
Social	***
Recreation	***
Family	****
Prioritizing	*****

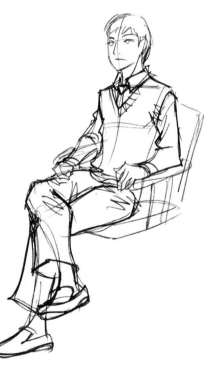

1 STRIKE A POSE
Philip has a very serious bearing, but he isn't too stiff. He gets a lot more relaxed behind a karaoke mic, though.

2 FILL IT IN
Draw the body structure. A cross-legged pose can get a bit tricky, but be sure that the bottom leg has proper proportions before drawing the other leg over it.

3 ROUGH IN THE DETAILS
When seated, the hem of the slacks rides up a bit. Even more so when someone's legs are crossed. The fabric bunches up at the bend of the top leg's knee.

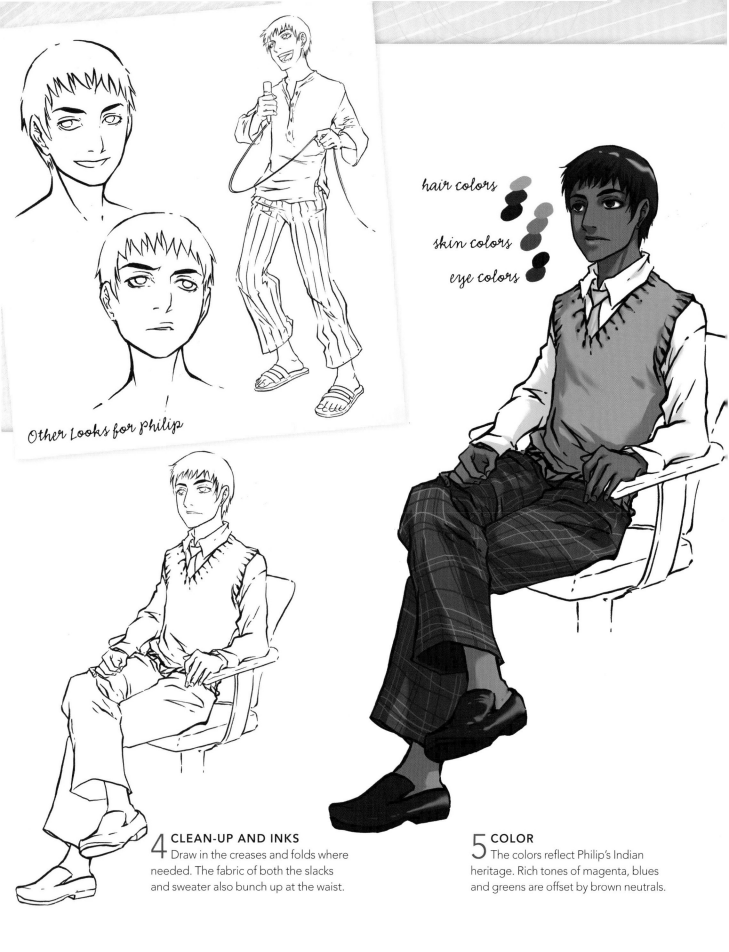

Other Looks for Philip

hair colors

skin colors

eye colors

4 CLEAN-UP AND INKS
Draw in the creases and folds where needed. The fabric of both the slacks and sweater also bunch up at the waist.

5 COLOR
The colors reflect Philip's Indian heritage. Rich tones of magenta, blues and greens are offset by brown neutrals.

The **FAMED**

Collin Porter gets his strengths from the same place he gets his weaknesses; his looks, style and social circle. Don't let his ease fool you—he worked for that cool exterior, trendy fashion sense and the perpetually confident laze to his walk. But hard work always pays off, and the result is a smoking girlfriend, as well as the attention of all of his peers. It may seem a little shallow, but Collin's a good guy at heart, and is magnanimously willing to invite any type to his famous house parties, or play the sensitive friend by offering a listening ear. He may not empathize all that deeply, and is more than occasionally guilty of having a big head, but at the end of the day he'll usually try to do right by others. And it certainly doesn't hurt that Odessa digs nice guys.

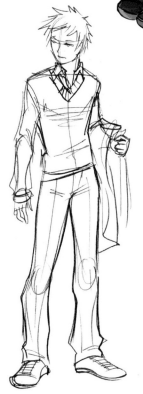

CONFIDENT AND COOL COLLIN	
Study	✱✱✱
Sport	✱✱✱
Social	✱✱✱✱✱
Recreation	✱✱✱✱✱
Family	✱✱
Confidence	✱✱✱✱✱

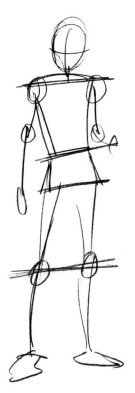

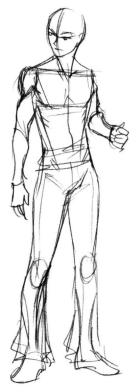

1 STRIKE A POSE
He's popular, confident and slightly cocky. He tends to stand around and slouch in a way that he knows looks good.

2 FILL IT IN
Collin is fit, but not laden with muscles. At this point, rough in the bottom part of the slacks to show how they hang down and away at the calves.

3 ROUGH IN THE DETAILS
The clothes are slightly fitted but not too tight. The pants are tailored and the fabric isn't as stiff as denim, so it doesn't bunch up that much around the ankles.

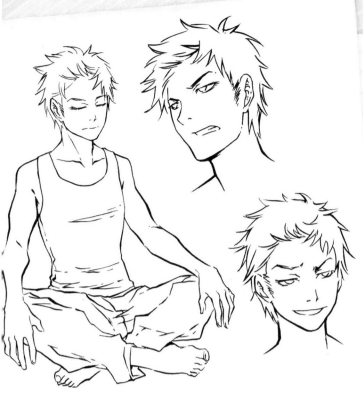

Other Looks for Collin

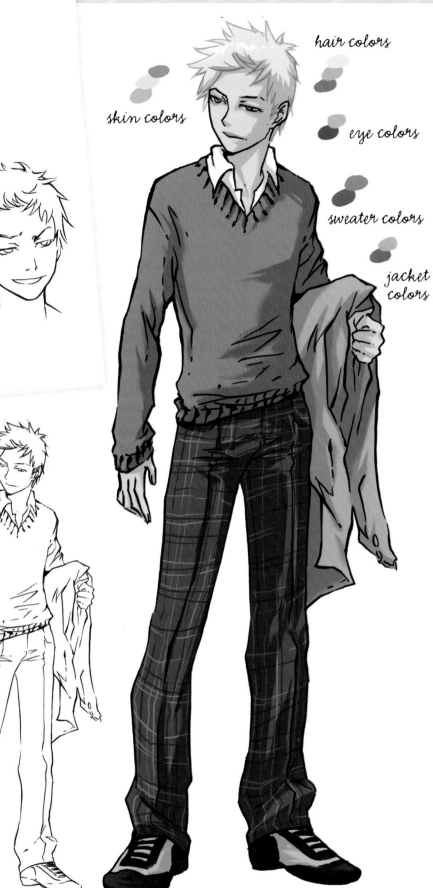

skin colors

hair colors

eye colors

sweater colors

jacket colors

4 CLEAN-UP AND INKS
The clothes are presentable but not crisp, so draw in the fabric folds of the sweater. The pants aren't perfectly pressed either so they need some creases as well.

5 COLOR
Collin likes whatever's trendy at the time. And those trendy colors go well with the tan and the blond hair.

PSEUDO PUNK

Confident, an occasional flirt and cool to a fault, March enjoys leather pants, rock star boots and cutting loose at parties. While his aloof air and over-accessorized style sometimes leaves people with the impression that he's just a pretty boy playing at being a rebel, March has yet to bother to tell them he just likes the clothes.

MARCH HAAS... COOL TO A FAULT

Study	**
Sport	***
Social	***
Recreation	***
Family	*****
Appearance	*****

1 STRIKE A POSE
March is almost always slouching, and gives off a very relaxed, bored attitude.

2 FILL IT IN
Place the facial features and rough in the body structure.

3 ROUGH IN THE DETAILS
Add more detail to the face and draw the hair, which March styles to be artfully messy. The shirt's collar is turned up, and the pants are cut at the shins to show off the boots.

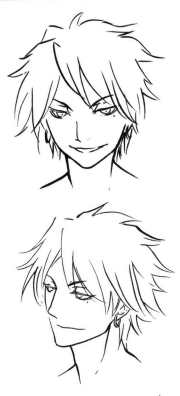

Other Looks for March

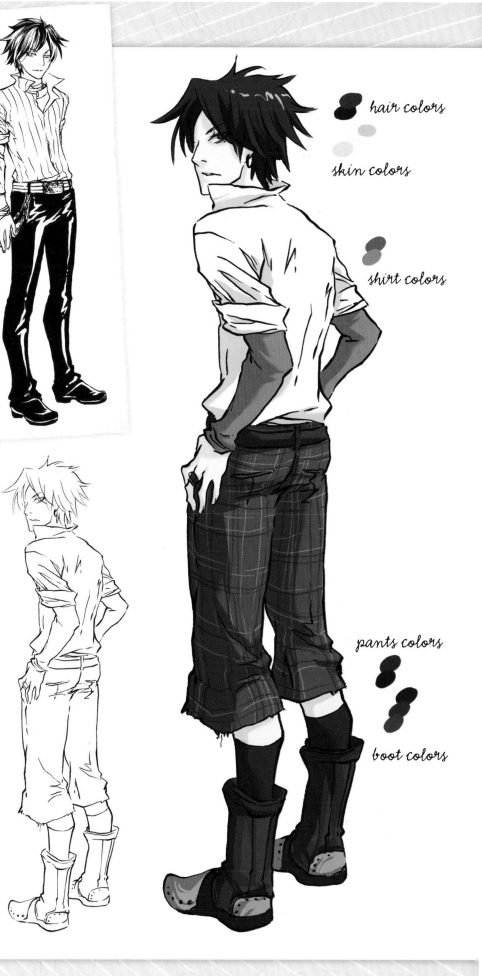

hair colors

skin colors

shirt colors

pants colors

boot colors

4 CLEAN-UP AND INKS
Get in those little details like stray threads and rough edges on the pants he didn't bother to hem.

5 COLOR
Overall, the palette for March is subdued—a lot of black and dark colors. It goes great with the pale-skin-and-black-hair look.

The **SOLITARY**

There's a theory that brain is superior to brawn, but Allister Schnider is absolutely certain of this. So if his penchant for spending all of his free time working out Boolean algebraic equations or reading books on the wonders of electronics sometimes gets him hassled, mocked, or even abused, Al is stubborn enough to take it and write it off as the lesser man's jealousy. Which isn't to say he wouldn't like to fit in a bit better, or dress a bit nicer, or have some idea what to do when surrounded by his peers. But all in all, he wouldn't trade a bit of his brain power for popularity, and instead holds out for the day when he's recognized for his accomplishments and contributions to science and society, above all else.

SMART AND SHY ALLISTER	
Study	*****
Sport	*
Social	**
Recreation	**
Family	***
Five-Year Plan	*****

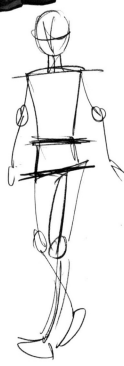

1 STRIKE A POSE
He tries to be serious, but has a social awkwardness about him. Al would prefer to sit at his desk with his laptop.

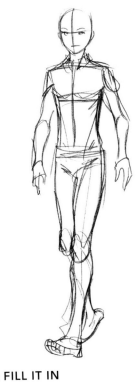

2 FILL IT IN
He's a bit on the scrawny side, so give him narrow shoulders, hips and everything else.

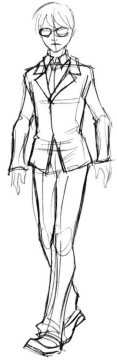

3 ROUGH IN THE DETAILS
Al tries to keep his clothes proper and neat. He prefers slacks over baggy jeans, and the slacks are always pressed so they shouldn't have many lines or creases.

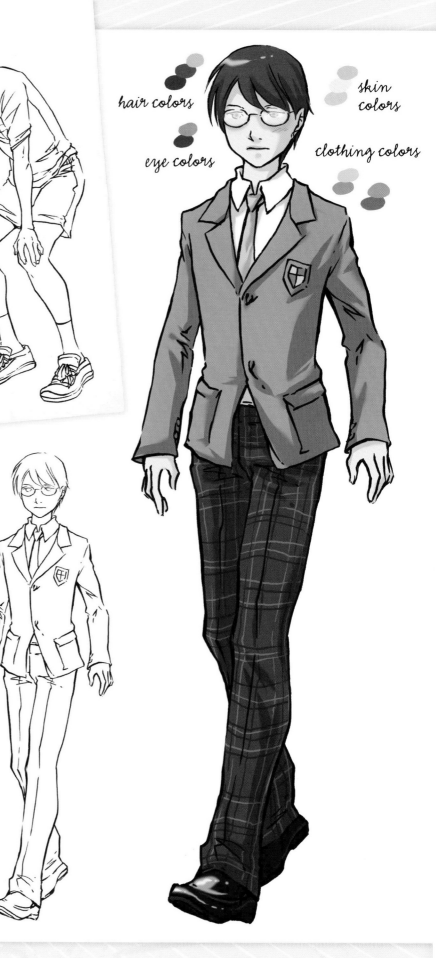

Other Looks for Allister

hair colors

eye colors

skin colors

clothing colors

4 CLEAN-UP AND INKS

The jacket creases at the shoulders and the bend of the elbows as Al walks. The slacks also crease with his stride, and there is a minimal bunching up of the fabric at the ankles.

5 COLOR

He doesn't know what would go with his pale skin and bright red hair, so he just sticks to neutrals and dark colors to play it safe.

TWO FRIENDS

Though not close enough that they are seen hanging out much, Teddy and Odessa's mutually extroverted and generous attitudes mean they get along pretty well. Odessa is always alert for the possibility of someone trying to get her attention as she passes, so when she heard Teddy call her name, Odessa slowed her walk until the blond girl caught up. The girls are glad to see each other; Odessa appreciates Teddy's ingenuity in making sure something interesting is always going on, and Teddy just appreciates everything.

Teddy and Odessa often cross each other's paths. Maybe at the same party, or maybe they were just shopping at the same store and decided to hang out.

1 STRIKE A POSE
Teddy is on the left and Odessa on the right. Their stances reflect their different personalities; Odessa stands straight but relaxed, while Teddy's extended arms show a higher energy.

2 FILL IT IN
Establish the angles of their faces and rough in the bodies. Teddy is slightly behind Odessa and is walking up to her, so her feet are on a higher plane. Their heads are almost level, though, since Teddy is the shorter of the two. Meanwhile, we want to be able to see Odessa's face, so she doesn't turn completely to face Teddy, and instead lets the other girl come up to her side.

3 ROUGH IN THE DETAILS
Add the facial features, hair and sketch in the clothes. Since Teddy is heading toward Odessa, her hair shows a bit of that movement. The rough pencils from step 2 are shown in blue, to make it easier to see the additional details of expressions, anatomy and the rough details of the clothes.

Think about how your characters are dressed and what their bodies are doing. Teddy's arms are set opposite her feet, another hint that she's walking. And don't forget the accessories; if the girls are dressed for walking around town, they'll need somewhere to keep the necessities.

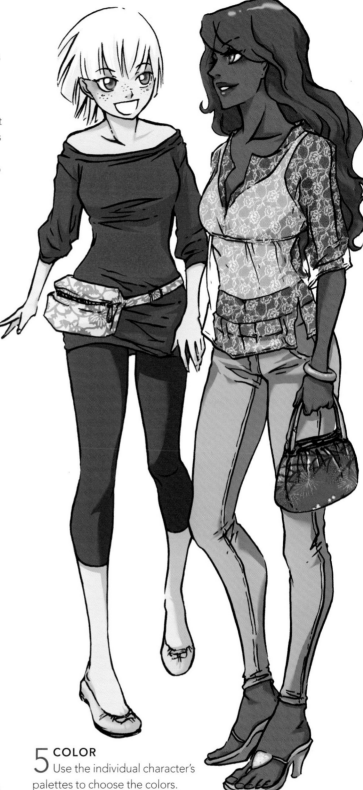

4 CLEAN-UP AND INKS

Add more detail to the clothes, faces and the overall image. Teddy's shirt is fitted and stretches under the chest, but the sleeves are baggy. The cloth also stretches across her hips because of the walking motion and being caught under the fanny pack. Odessa's clothes have some wrinkles as she bends her limbs, but she generally has fewer lines on her clothes.

5 COLOR

Use the individual character's palettes to choose the colors.

GROUP of GIRLS

And then sometimes girls don't get along...though Trey doesn't seem to be aware of the offense she caused when she won the role of female lead that was clearly meant for Susan. Luckily, Beck is there to set things straight, and deflects the one-sided argument before it can begin. Meanwhile, Ruth isn't involved in any of it, and doesn't have much interest in poking her nose in.

1 STRIKE A POSE

With this many characters, make sure they are all in proportion to each other and to the objects that appear in the scene. I wanted to include all the girls here (right), but it was just too busy. In the revised sketch on the far right, notice that everyone has a different but fairly natural pose, except for Susan, who has a bit of extra drama in her stance. The composition itself is also a bit uneven, which lends interest to a group shot like this; characters who line up evenly are boring.

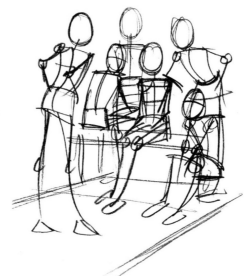
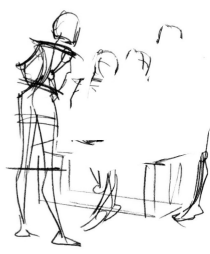

2 ROUGH IN THE DETAILS

Beck's right knee is in the center of the bench, so her left foot needs to be between the bench legs. If her foot were longer or shorter, it wouldn't look right. The same goes for the placement of the other three girls. Because she is in the foreground, Susan's feet should be on the lowest plane in this scene. And what you can see of Ruth's feet appears on the highest plane of the image.

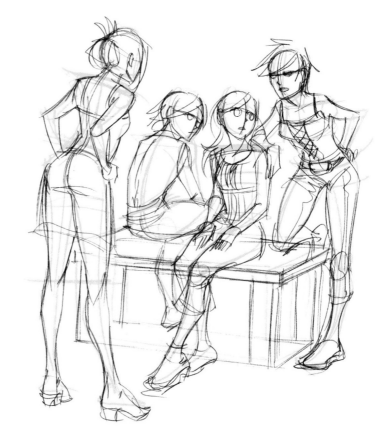

3 CLEAN-UP AND INKS

Refer to the individual character tutorials on how to ink the way their clothes hang. The shadows and blemishes on the ground add some texture.

4 COLOR

Use the individual character's palettes to choose the colors.

Clearing her throat wasn't necessary; Susan had a commanding stance in almost every situation, and the way she planted herself in front of Trey broke up the group's conversation immediately.

GROUP of GUYS

Allister is just a little too no-nonsense for his own good! Part of the reason he has such a hard time making friends is that people only seem to want to talk to him when he is clearly already very busy doing something else. Luckily, March is the persistent type and doesn't much care if he's being a bother. In the background, Collin takes note, but has other places to be.

1 STRIKE A POSE

For this scene of three people, make the composition triangular, with two seated figures and one standing. Rather than have all three characters interacting as was designed in the first sketch, the sketch on the far right has more action, and I like having that sense of movement. And even though Collin is just walking by, he glances toward Al and March, so he's still somewhat involved in the scene.

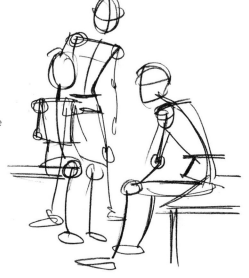

2 ROUGH IN THE DETAILS

Check the scale of the characters based on their position in the scene. March and Al are close together, so they have almost the same proportions. Collin is in the background at a slight distance, so the scale of his body is smaller than the other two. Also, don't forget what the characters carry with them. The guys can be assumed to have their wallets in a pocket somewhere, but Al wouldn't carry his trusty laptop around without a case to keep it safe.

3 CLEAN-UP AND INKS

Refer to the previous character descriptions, and you can see that the inks still follow those guidelines. Al has neatly pressed slacks and a long-sleeved shirt. March has the stylishly rumpled clothes and Collin is trendy and presentable, but his clothes aren't super crisp. The shadows and blemishes on the benches also make them look more like stone.

4 COLOR

The characters' color palettes have been established in their individual sections. Try to use different colors for the each one while keeping their individual palettes in mind.

March was here to pester him again, it seemed. Probably about what had happened at Collin's last party. Allister already didn't want to hear about it, and didn't even bother moving his fingers away from the keyboard.

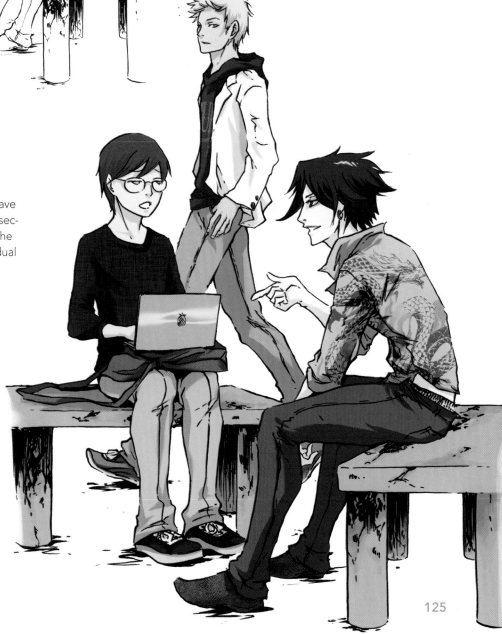

A COUPLE

Some couples just look good together, and Odessa and Collin certainly fit that bill. Something about them seems interesting, like they might live the sort of lives you'd read about in a magazine...or in a manga. With Collin's big head and Odessa's sly confidence, their relationship has as much push and pull as you would expect to find in such a young pair, but that same element also keeps them interested in each other. Possibly for years to come.

1 STRIKE A POSE
Drawing a couple is trickier than drawing two people hanging out. Couples have moments of close interaction like holding hands, hugging or sitting close to each other. Collin's outstretched leg is used to line up the figures.

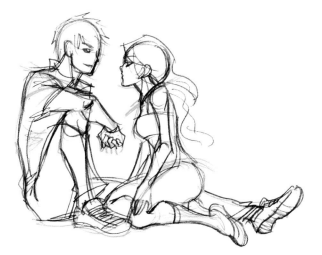

2 ROUGH IN THE DETAILS
Their faces are not really in profile. They are almost at a two-thirds angle, but Collin faces the viewer and Odessa is turning away. His outstretched leg is in the background, so it's on a slightly higher plane. Odessa's legs are on a slightly lower plane and Collin's other foot is lower still.

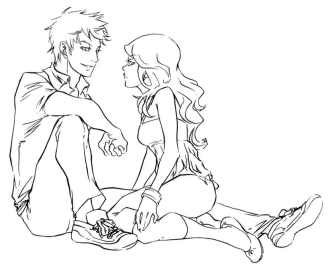

3 CLEAN UP AND INKS
Once all that proportion stuff is figured out, add in the clothes. In Odessa's case, her clothes fit snugly, so keep the lines smooth. The bottom part of her shirt flares out, though, so the fabric lines aren't as clean. Keep Collin's clothes from looking wrinkled by keeping the creases to a minimum, adding them in where the fabric stretches at his shoulder and where it bunches up at the waist.

As she leaned over, Collin still wasn't sure what that smile on Odessa's lips really meant.

4 COLOR
The light source is mostly coming from a point behind Collin, so his face and most of his front is in shadow.

Here is the same pose from another angle. The hands in the foreground are on the lowest plane this time, and the leg is on a slightly higher level.

Ink this like you would the first example, drawing in the appropriate fabric creases.

The light source is still behind Collin. The fabric creases get some shadow and their arms are also casting shadows away from the light.

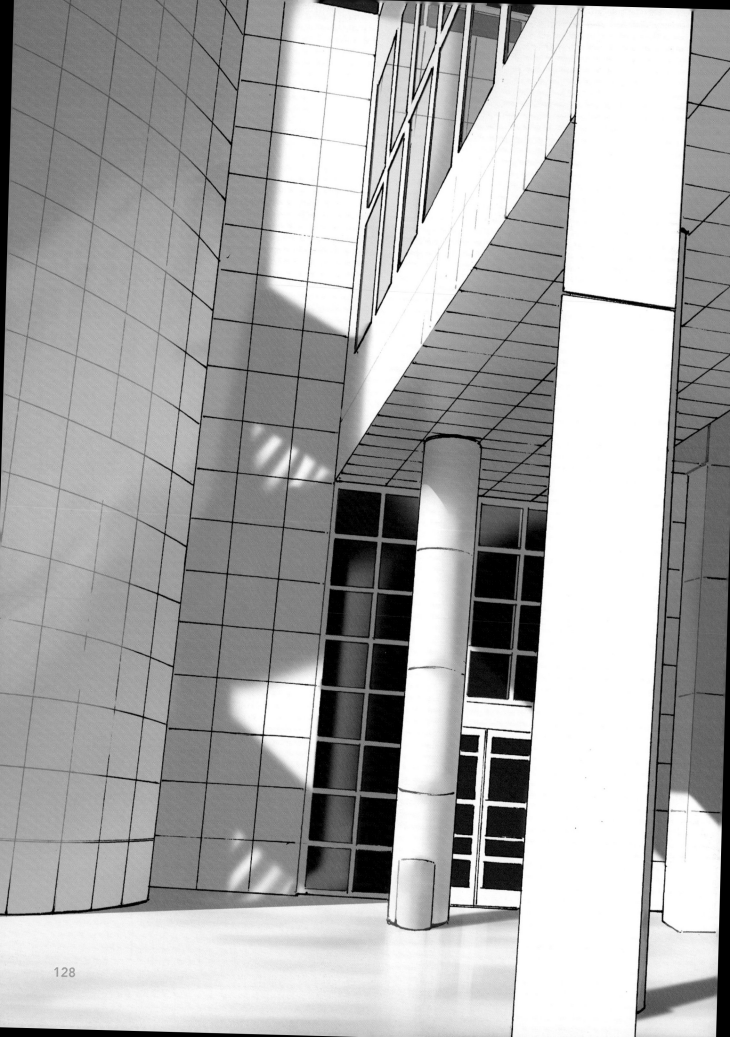

6 | Setting the Scene, Step by Step

Settings and backgrounds, whether modern and familiar, or fantastical and unheard of, are a wordless way to convey almost infinite information about your world. Something as simple as what sort of paraphernalia is tacked to public wall space can let the audience in on political situations or when the next big social event will be. So don't be content to leave nothing but white space behind your characters! Drawing a setting is more technical than drawing a character, but take the time to make use of all of these possibilities.

This section helps with some of the technical aspects of setting a scene, and while it certainly can't contain even every possible genre, the information within can be applied nearly anywhere. By using the grid shown to create a classroom, you can just as well make a flea market or an ancient treasure trove, and whether drawing the city skyline of a modern metropolis or an alien maze of skyscrapers, the same rough principles can be applied. Finally, this section covers how to use reference photos to your advantage in transforming real-life places into the shops of your fantasies, and by letting said fantasies run wild, you can then decorate your characters' rooms to display their individual tastes and personalities.

Understand Perspective

Perspective describes the way we see things in our environment. In art, there are certain guidelines used to draw proper perspective so that the relationship between objects appears three-dimensional when the picture is in fact on a two-dimensional surface.

KEEP THINGS IN LINE

The figures illustrated in the examples of one- and two-point perspective are in proportion with each other. That scale is established by the horizon line intersecting the same part of the body in all the figures. For both examples, the line intersects the shoulders.

CREATE A PERSPECTIVE GRID

To create a perspective grid, start with a simple dot (vanishing point) on the horizon line. Use the vanishing point as the origin for a number of lines that radiate outward.

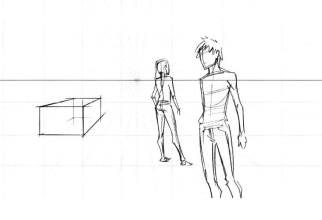

ONE-POINT PERSPECTIVE

The vanishing point can be placed anywhere on the horizon line. It really depends on the angle at which you want to show your figures and objects. The vertical and horizontal lines help line up objects in the grid.

TWO-POINT PERSPECTIVE

Add another vanishing point to the horizon line. It's better to use two-point perspective for wide shots, since it gives a larger sense of space.

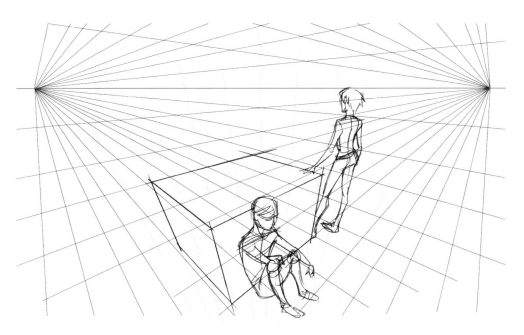

THREE-POINT PERSPECTIVE

The third vanishing point will be above or below the horizon line. All the lines in your perspective grid may look confusing, but it allows for a more dynamic angle.

↓ Here is a finished scene using three-point perspective.

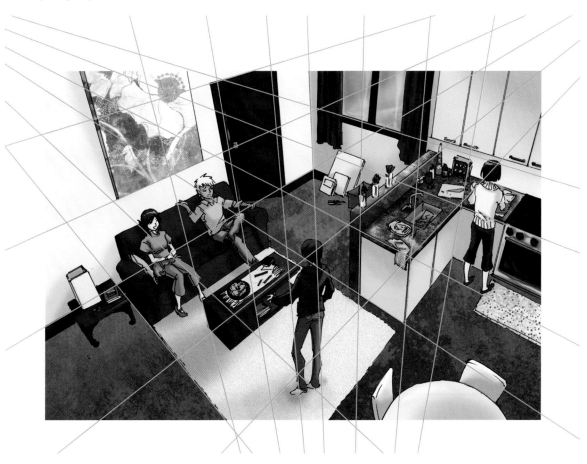

The SKYLINE

Backgrounds are vital if you want to tell a story, and if your characters ever go outside, chances are they will see a skyline, and you will need to draw it. A skyline can convey everything from a very specific city to a general time and place. Use this to your advantage to set scenes or draw dramatic shots.

1 GETTING STARTED

Draw a horizontal line to keep things straight and sketch simple blocks to represent buildings. Buildings close to each other should have different widths and heights. Take up the space between buildings with more structures in the background. This gives the feel of a congested, crowded city. You can add more detailed structures in the foreground to give a better sense of the urban sprawl.

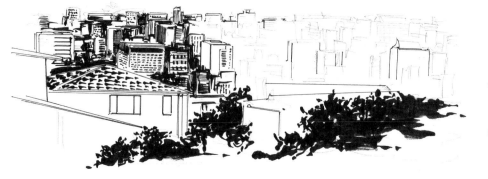

2 ADD DETAIL

The easiest way to add detail to high-rise buildings is to create the look of windows. Use vertical or horizontal lines and change it up. Break up the lines or leave them whole, change the spacing between them or make them larger or smaller.

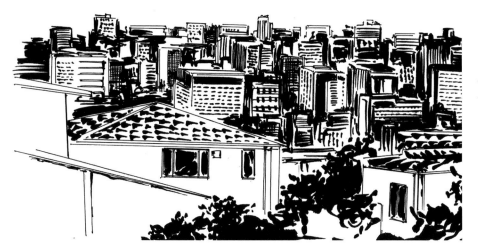

3 FINISHING TOUCHES

Finish the inks and add in other details, maybe some mountains in the distance if the scene calls for it. This is a generic city skyline, but certain cities have landmark structures that should be added in for skyline shots.

The **CLASSROOM**

It's a fair bet that you have spent much of your time in a classroom at one point or another, a history many people share. This makes it a popular setting for telling stories, but also means your audience knows just what it should look like, and will be able to tell if you're being lazy. The idea of drawing thirty desks and chairs all in proportion might sound daunting, but here are some useful tips to help.

The chair-desk is the main element of this scene, so have a reference image of it

1 DRAW A ROUGH SKETCH OF THE SCENE
The proportions and perspective don't even have to be right. You're just deciding on the scene angle and the placement of items within that scene.

2 SET UP YOUR GRID
Draw a vanishing point and start creating a grid.

3 DEVELOP THE GRID
This scene uses two-point perspective, so a second vanishing point is in order.

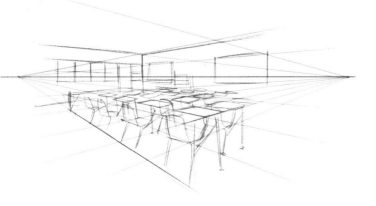

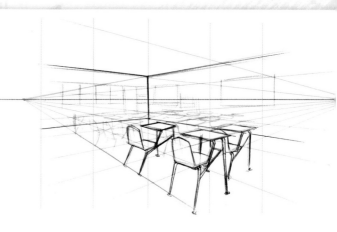

4 ROUGH IN ELEMENTS IN THE ROOM
The trickiest bit in this scene is the large number of chairs, so focus on that first. The desktops are easy enough to place. They are basically created by the spaces between the lines of the perspective grid.

5 DEVELOP THE DESKS AND CHAIRS
As far as the chairs and legs go, it's a matter of choosing a guide line and drawing the elements against those lines. The bottoms of the chairs all run along the same line, and the feet of the chairs run along another line.

6 CLEAN UP AND FILL IN
Clean up the lines, and once the chairs are drawn, add more detail to the rest of the room.

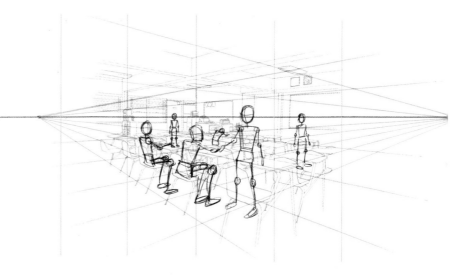

7 ROUGH IN THE SKELETAL STRUCTURES OF FIGURES
To keep things to scale, the horizon line should intersect the same point in the figures. In this example, the horizon line goes through the heads, except for the two sitting figures.

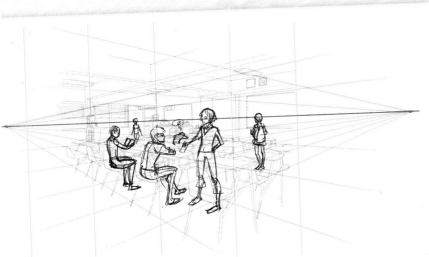

8 DEVELOP THE FIGURES

The perspective grid provides a guide for the seated figures. The lines from the left-hand vanishing point go through the same points in the body. The feet of all the characters also line up with the grid lines and this keeps them all in proportion and to scale within the scene.

9 CLEAN UP THE PENCILS AND ADD INKS

The numerous elements can make the image look messy, so take time to refine the image. Don't rush the inking process, or you could end up inking the wrong lines. Give the ink time to dry before erasing the pencils.

10 FINISHING TOUCHES

Add detail with inks or color.

The **COFFEE SHOP**

While it's not uncommon for manga artists to skimp on backgrounds, taking the time to draw them well is important to fleshing out your art and adding depth to the world in your story. Reference photos are your friends here, as it's easy to make windows into walls and stone into steel, allowing you to create any kind of building.

HOLD YOUR INTERNET HORSES!

You can't just copy any photo you find online, in books or in magazines. Take your own photos and keep an image library of reference photos. That gets rid of the copyright issue and keeps you from getting sued. Everybody wins.

USE A PHOTO REFERENCE
You don't have to reinvent the wheel. If you have to draw a store, a coffee shop or another setting already in existence, why spend time making it up when you can use a photograph?

1 COPY THE LINES OF THE BUILDING'S FACADE
The perspective grid (with an off-screen vanishing point) proves the proportions are correct. And why wouldn't they be? The building exists in real life, after all.

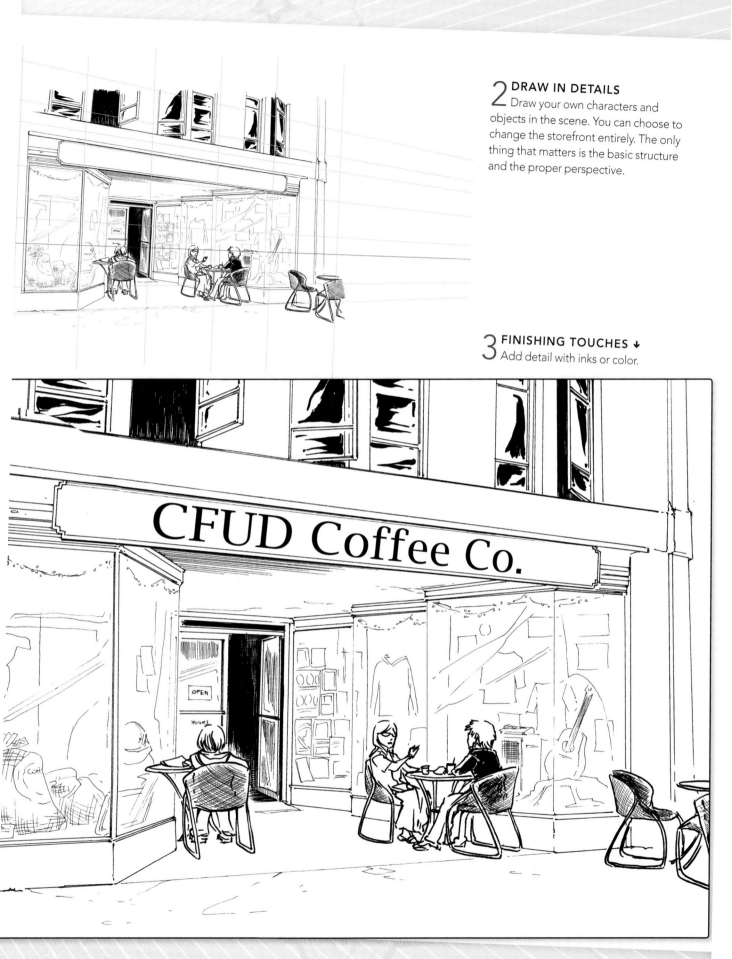

2 DRAW IN DETAILS
Draw your own characters and objects in the scene. You can choose to change the storefront entirely. The only thing that matters is the basic structure and the proper perspective.

3 FINISHING TOUCHES ↓
Add detail with inks or color.

BEDROOM CHIC

I probably don't need to explain how much a bedroom can and should convey about your characters. Whether plastered with posters of their favorite bands or stark and empty like their souls, you may learn as much about your characters from decorating their rooms as your audience does.

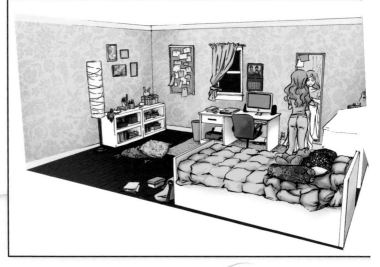

1 CREATE A FLOOR PLAN
Play around with the large elements going into the space. Having a floor plan helps you know where things are located when drawing the space from different angles.

2 DRAW A ROUGH SKETCH OF THE SCENE
The proportions and perspective don't even have to be right. You're just deciding on the scene angle and the placement of items within that scene.

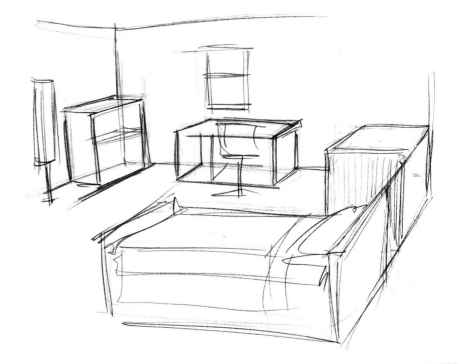

3 START A PERSPECTIVE TEMPLATE

This kind of scene uses two-point perspective, so start with the horizon line and a single vanishing point.

4 DEVELOP THE GRID

Add the other vanishing point. In this image, the point is so far off to the side that it isn't really visible, but that's how far out it needs to be for this particular setup.

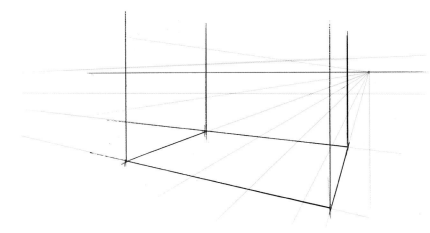

5 ESTABLISH THE SHAPE OF THE ROOM

Use the perspective grid to build the walls and floor of the room.

6 SKETCH IN THE MAIN PIECES OF THE ROOM

Add in the doors, windows and other blocky pieces. Lining them up with the grid lines makes this easier. Add more lines coming from the vanishing points if you need more guides in lining up the objects.

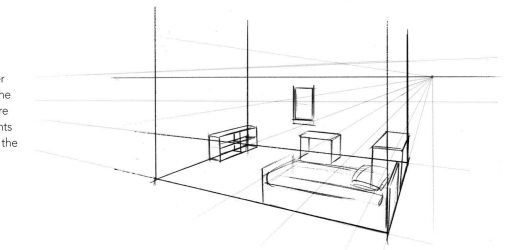

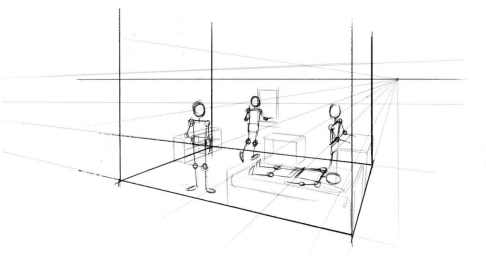

7 ROUGH IN OPTIONS FOR YOUR FIGURE

Draw the figure on the bed first to make sure that it fits on the bed and is in proper proportion with the room and furniture. Make all the other figures the same size as this one. The line of the figures' shoulders, hips and knees should match up with the vanishing points.

8 CHOOSE YOUR POSE

Choose a final pose and location for the figure in the scene.

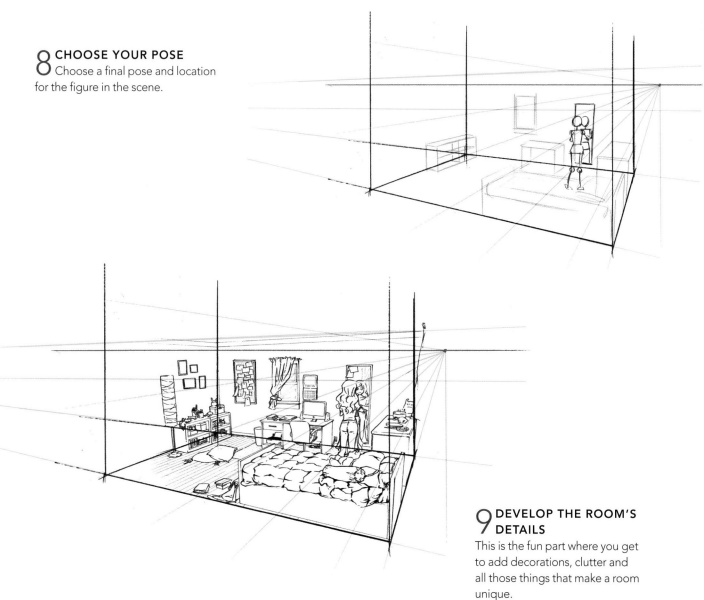

9 DEVELOP THE ROOM'S DETAILS

This is the fun part where you get to add decorations, clutter and all those things that make a room unique.

10 DEVELOP PERSONALITY WITH COLOR
Use accessories and color to give your environment a sense of personality. Trey's room is full of spring colors, and the gratuitous use of pink wallpaper definitely gives off a girly vibe.

This started as the same room, with the same layout and same basic types of furniture, but in its finished stage it clearly reflects a different personality. Ruth's walls are neutral, and sports awards and memorabilia make up most of her decor rather than throw pillows and stuffed toys.

Index

Look for these other fabulous titles from **IMPACT**!